ARTIST'S ACKNOWLEDGEMENTS

John Hall would like to acknowledge the encouragement and knowledge of his early art instructors in Calgary: Illingworth Kerr, Marion Nicoll, George Wood, and Ronald Spickett. He would like to extend thanks to his various art dealers over the years: David Tuck and Lynne Wynick, Douglas MacLean, and David, Alan and Ian Loch. He is grateful to the Board of Directors and staff of the Kelowna Art Gallery, including curator Liz Wylie, for making this project a reality. Also, to his friend and artist-colleague Alexandra Haeseker, for her support and the text in this book about their time and work together in Mexico. Lastly, and most importantly, he thanks Joice M Hall for her fifty-plus years of unwavering support and encouragement.

KELOWNA ART GALLERY ACKNOWLEDGEMENTS

This book has been published on the occasion of a solo survey exhibition of paintings by Canadian artist John Hall at the Kelowna Art Gallery, 16 April to 10 July 2016. John Hall: Travelling Light will also appear at Nickle Galleries, University of Calgary, Calgary, Canada from 26 January to 29 April 2017.

On behalf of the Board of Directors and staff, I would like to thank John Hall for his dedication and contribution to this project. Thanks to our curator, Liz Wylie, for her enthusiasm and rigour realizing the exhibition, and for her essay, "John Hall: A Painter of Modern Life". In addition, we are delighted and grateful to include a text by Canadian artist Alexandra Haeseker, a long-time colleague and collaborator of Hall's. Thanks to Christine Sowiak, Chief Curator of Nickle Galleries, for her interest in and commitment to bringing this exhibition to Calgary, which was Hall's home town for decades. We also extend our deep gratitude to the lenders of work to this exhibition, both institutional and private, without whom this exhibition would not be possible. Thanks as well to the artist's dealer, Loch Gallery, for their generous support of this project. As always, thanks to all Kelowna Art Gallery staff, who work collaboratively to realize important projects such as this one.

Finally, we are deeply indebted to all our supporters, members, volunteers, and sponsors for their continued support. The assistance of the City of Kelowna, the Canada Council for the Arts, the British Columbia Arts Council, the Province of British Columbia, School District # 23, the Regional District of Central Okanagan and the Central Okanagan Foundation allows us to bring important exhibitions and publications such as John Hall: Travelling Light to fruition.

Nataley Nagy
Executive Director

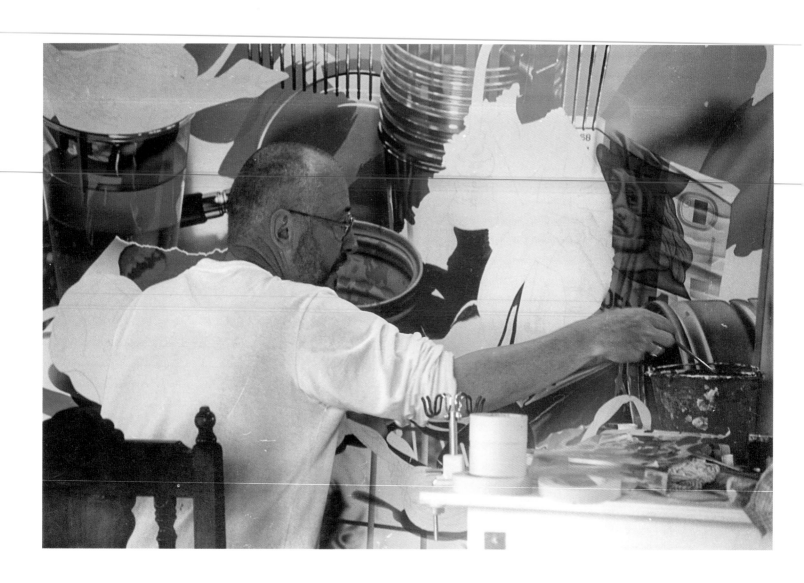

John Hall in his Mexico
studio at work on *Sandy
(a Still Life Portrait)*, 1989.

FOREWORD

Liz Wylie

The people of Kelowna, British Columbia in Canada have been fortunate to have artist John Hall living in their midst for the last 16 years. He is an essential ingredient to the art community here, and we have all benefitted from his knowledge and eagerness to discuss art and artists. It has been an honour and pleasure for me to work on this survey show of his entire career. This has required me to spend many hours in Hall's company, drinking coffee and talking, looking at image files, and making decisions together. The entire process has been smooth and enjoyable as he spent a great deal of time organizing his documents and image files, and never seemed to tire of answering my questions.

We are very pleased to be working with Black Dog Publishing to create the book that accompanies this exhibition and extend our thanks to them for their good work, attention to detail, and excellent design and production values.

My text in this book is chronologically organized, and discusses each series as it came into being, its meaning, and its reception. Every phase of Hall's career has been covered, with a special emphasis on the artist's relationship to photography. From at first avoiding it altogether, then eventually beginning to use it as an aid, and finally embracing digital photography and image manipulation on the computer, this one strand to his work forms a fascinating lens from which to view his overall oeuvre. I wish to acknowledge the work of previous writers on John Hall, particularly Derek Besant and Nancy Tousley, whose insights about his work lit up my path for me as I entered into a journey to decipher it for myself.

The other text included here is by Hall's colleague and friend, the Calgary-based artist Alexandra Haeseker. She has written eloquently, vividly evoking their years together working in Mexico. This was an intense and wonderful run of years for both Hall and Haeseker and their spouses and she has done very well at conveying the feeling of this to a reader.

I extend my appreciation to the Board of Directors and staff at the Kelowna Art Gallery for their support of this project. It is a stretch for a small community art gallery to take on large, ambitious projects, and I am grateful to everyone who played a role in bringing this show and book to fruition.

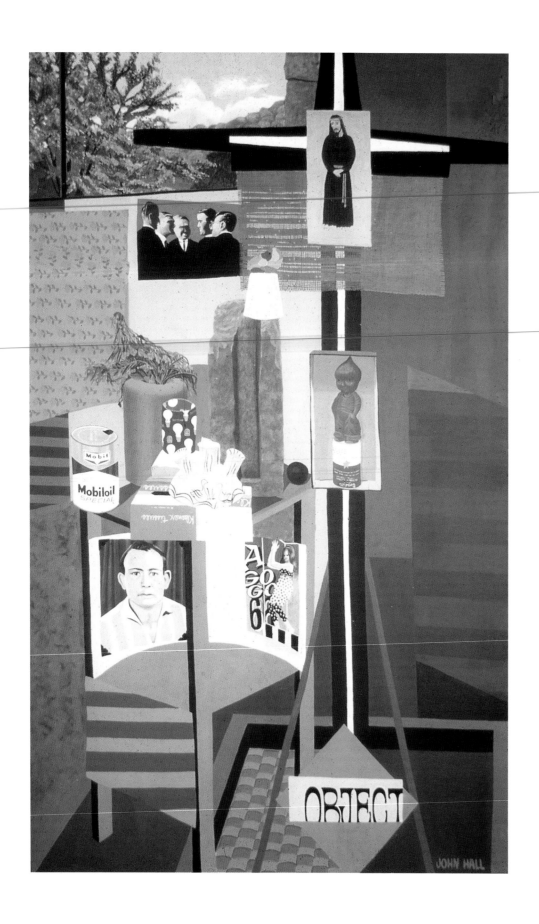

Untitled, 1996,
acrylic on canvas,
305 x 183 cm.

JOHN HALL:
A PAINTER OF MODERN LIFE

Liz Wylie

The substance of painting is light.
—Andre Derain

When the French poet Charles Baudelaire wrote his essay "The Painter of Modern Life" in 1860, he was attempting to describe how art should become modern (as in the hands of his friend Edouard Manet, for example), and no longer look back to history, especially the ancient past. Instead of painting something eternal, he urged artists to depict a fleeting detail in order to convey a passing mood. At the same time, just as cafes were first popping up in Paris, Baudelaire also developed the notion of the *flaneur*, that enduring invention of the detached observer of urban life. With his seemingly mundane, everyday still-life subjects, Canadian artist John Hall could be seen as filling this double bill—being a detached observer, and painting fleeting light effects on quotidian subjects. He has become nationally known for his high realist paintings in which he has captured convincing highlights and reflections on everyday objects. The survey exhibition of John Hall's work and this book that accompanies it present the opportunity for a careful look at his production to date, and a chance to consider the overall trajectory of the five decades of his painting practice. One specific thread to be followed in this text will be Hall's relationship with photography over his long career as an artist. From initially avoiding it completely—seeing it as a cop-out or cheating—Hall eventually turned to the camera as a tool or aid. Much later he embraced digital photography and Adobe Photoshop™ and gained a whole new way of working with his subjects.

In terms of those subjects, Hall has focused exclusively on still life, which has likely been a decision at least partly based on pragmatics. As American realist Daniel Sprick said when asked why he did not paint living subjects that were in motion, "Painters who go in for verisimilitude need to start with things that cooperate."[1] Within the range of choices available to a painter of still life, Hall has run the gamut, and one could compile a long list of his depicted objects, ranging from other people's treasured keepsakes to toys, household objects, masks, figurines, stones, candies, donuts and fruits and vegetables. However, looking at his work based on what he has painted will only get us so far in penetrating the full meaning of his art. This question of interpretation is not a simple one, and has become thornier as his work has evolved, as will later be discussed (or perhaps thrashed out would be more accurate). Hall himself has continually insisted that his subjects are not important to him; it is in fact the effects of light on objects that move him and inspire him.[2] While working on this project, at first I took this statement about the unimportance of subjects for Hall at face value. But later I began to question it, particularly in the light of his work from the last decade.

1960s

Hall's training in the mid 1960s at the Alberta College of Art and Design was a tradition-based one. He was aware of contemporary developments in art, however, and found them all tremendously exciting. It is jarring therefore to think of Hall and his peers actually drawing from plaster casts in their classes—something we generally associate with the academic tradition and instruction of the eighteenth and nineteenth centuries. But his teachers—two important ones for Hall were Marian Nicoll and Ron Spickett—were also aware of developments in the contemporary art world, so he was not trained by backward-looking academicians.

The artist's first paintings after art school were untitled canvases, ten feet tall by six feet wide. Each was a visual montage of everyday objects. Hall was excited by the large scale, flat, bright colours and everyday subjects of Pop art, which was headline news at this time. Hall's objects are depicted in one plane and with a flat, even paint handling. The artist realizes now that he was limited by living in a small population centre with no museums displaying great masterpieces, and he had not yet travelled to larger cities to see art. Years later he saw that his early paintings lacked surface definition because he had just not experienced very many original paintings, mostly only in reproduction in books and magazines, and in 35 mm slides, so he had no idea yet of the possibilities of this aspect of painting.

Concurrently with this group of paintings, Hall worked on small drawings done *en plein air* of grotty street scenes and urban locales, which Jack Kerouac surely would have called "beat". But far from being "on the road", Hall was in fact ensconced in a domestic context. He and fellow artist Joice Hanak (now Joice M Hall) had married in 1964, and their daughter Janine was born in 1965 (with their son Jarvis following in 1967). After the couple's graduation from the ACA, they went as a family to Mexico where John Hall studied for the 1966 year at the Instituto Allende in San Miguel de Allende. He continued to work on his street scene drawings and montage-like paintings while in Mexico. Living in San Miguel de Allende was a highly positive and stimulating experience for Hall, and he would be drawn back there in

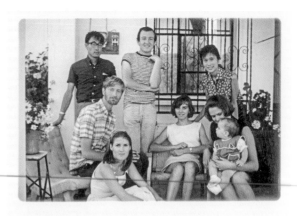

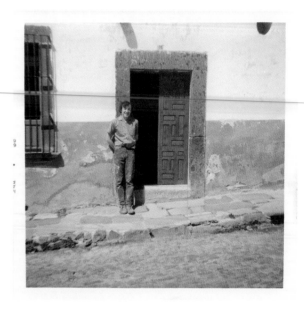

John Hall, top row centre, in San Miguel at the Instituto Allende, 1966. Joice Hall is in the middle row, second from the right. A friend holds baby Janine Hall.

John Hall outside the entrance to their rental house on Calle Umaran, in San Miguel de Allende, 1966.

John Hall's painting *Garbage Triptych* (now in the collection of the Nickle Galleries, University of Calgary, Alberta) in progress in his studio, Ohio Wesleyan University, Delaware, Ohio, 1969.

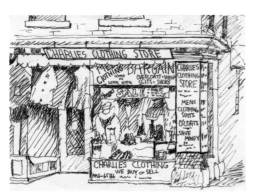

years to come. The entire flavour of life there and the Mexican people and their culture made a memorable impression.

Once back in Calgary, Hall began hauling big elements of trash and detritus into his studio so he could work on a large scale, and from life, but be indoors—a practical consideration particularly given Calgary's severe and long winters. Hall's paintings of these materials were enormous, in keeping with serious, ambitious art of the day. One specific inspiration at this time for the artist was the work of American artist Alfred Leslie, who also worked on a large scale, with a kind of street-tough, deadpan mood, and often in *grisaille*.

In 1969 Hall was hired for a year to teach art at Ohio Wesleyan University in Delaware, Ohio, so the family relocated there temporarily. This gave him a chance to visit nearby American art museums, and during reading week he was able to spend a week in New York, seeing museums and galleries. He was excited by various exhibitions and works on display by the American New Realist painters, and these artists formed a sort of meta-context for his own work in his mind. Artists such as Richard Estes, Audrey Flack, Ralph Goings and Philip Pearlstein would be of abiding interest to him. Pop art of the 1960s had a huge role in granting permission to artists wishing to pursue representational painting, especially in the face of the dominant art forms/avenues also in their ascendancies at the same time—Minimalism and the various forms of Conceptual art. The so-called New Realism of the 1970s was a bit like the Pop art that preceded it, but pushed mimesis to a further extreme. While in Ohio, Hall created a gigantic triptych measuring six metres long, which is now in the collection of the Nickle Galleries at the University of Calgary. This work is somewhat more elegant in composition and feeling than *Garbage Triptych*. The remnants and torn and bent hunks of cardboard and scraps of fabric are arranged in such a way that one thinks of a bird or angel, perhaps from Medieval art. The work is completed with pale, delicate painted *trompe l'oeil* cast shadows from these elements on the white ground of the canvas.

Charlie's, c 1968,
ink on paper, 13 x 20 cm.

Muro, 1966,
ink on paper, 15 x 20 cm.

Taxi, c 1968,
ink on paper, 13 x 20 cm.

Garbage Triptych, 1969,
acrylic on canvas,
122 x 305 cm.

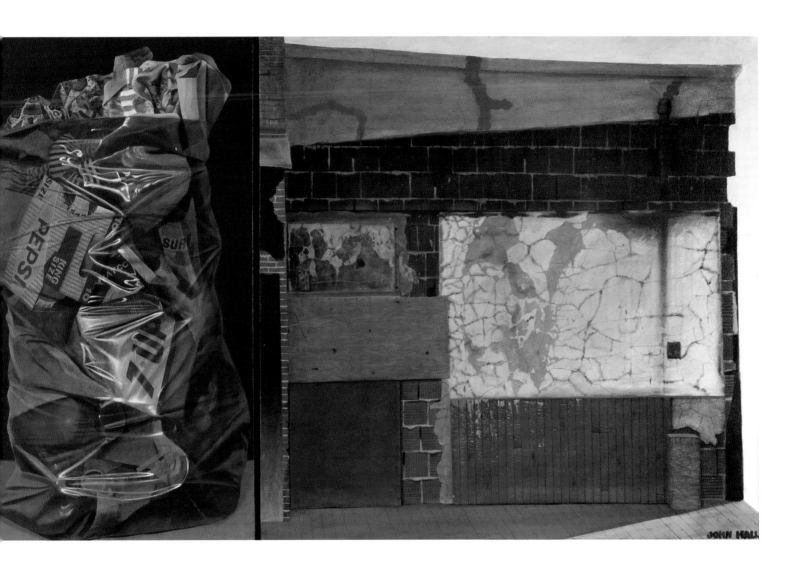

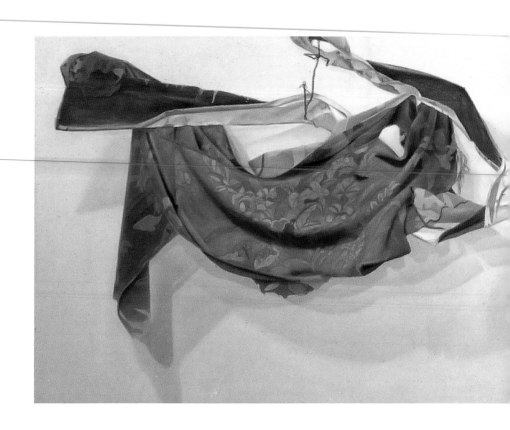

Untitled triptych, 1969,
acrylic on canvas,
183 x 610 cm.

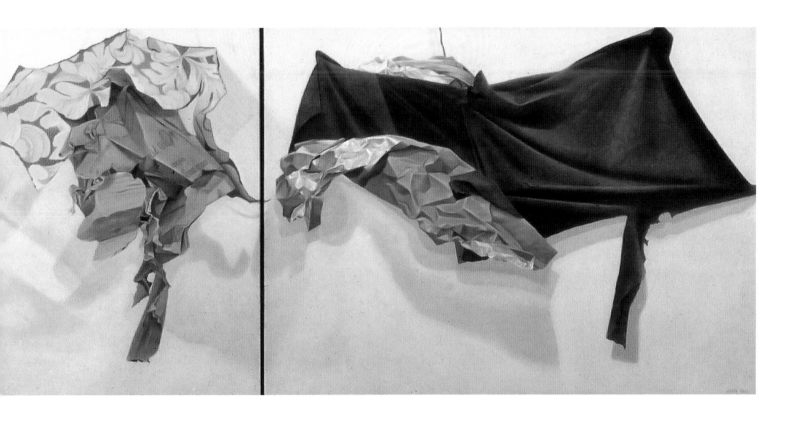

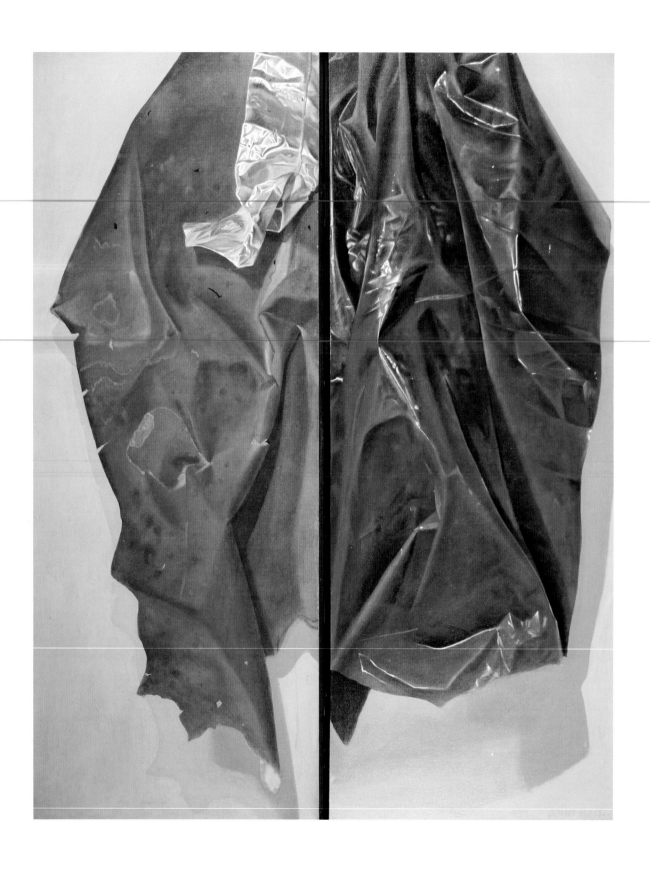

Untitled Diptych, 1969,
acrylic on canvas,
183 x 137 cm.

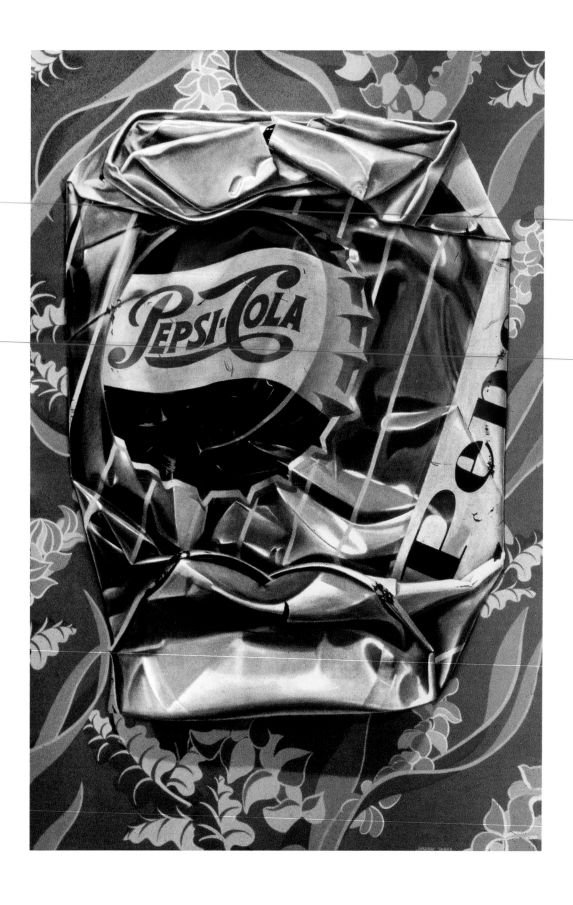

Pepsi, 1970,
acrylic on canvas,
244 x 183 cm.

1970s

With a year spent in the USA under his belt, the beginning of the 1970s found Hall back in Calgary, where he began teaching, first at the Alberta College of Art that year, then at the University of Calgary. He was hired full time at the university the following year, in 1971, and remained there until 1998. He continued with his large "garbage" paintings, evidently achieving traction and mileage from his inert subjects that smacked of urban grit—a kind of social-realist commentary writ large. There was nothing traditional or academic about these grungy subjects; they were immediate, of the moment, and without historical referents. Hall's giant flattened Pepsi can painting of 1970 is an excellent case in point. At two and a half metres in height it is heroic in scale, yet depicts a crushed pop can—a debased and mundane subject.

Another rather bizarre but impressive and huge painting from this same time is Hall's *Doll*, a triptych again, with two greatly enlarged plastic roses flanking a frontally arranged classic kewpie doll. In *Doll*, the colours have brightened and seem to glow, in part due to the hues inherent in the objects depicted, but generally Hall would pursue a more high-chroma palette from this point onward.

In the mid-1970s Hall made some transitional works, still keeping the integrity of the picture plane intact, so with only a shallow space portrayed, and with slight layering effect made from depicting looped strands of fabric and other materials, along with various objects. All of the paintings in this period were made by constructing maquettes using real materials, then painting by observing these small pieces. No intervening photography was utilized. A beautiful example of one of these works is *Pilot*, from 1976, in which the various materials and items seem to spill forward from the shallow space of the work, as though extending into the viewer's own environment.

John Hall's Calgary studio in 1972. The maquette of debris for his painting *Drum* is on the end wall, with the painting itself on the left, and a mirror to obtain a larger view of the work in progress is hanging on the wall on the right.

The worktable in the artist's studio in Calgary, 1970s.

Hall's Calgary studio in 1976, with the painting *Pilot* as a work in progress.

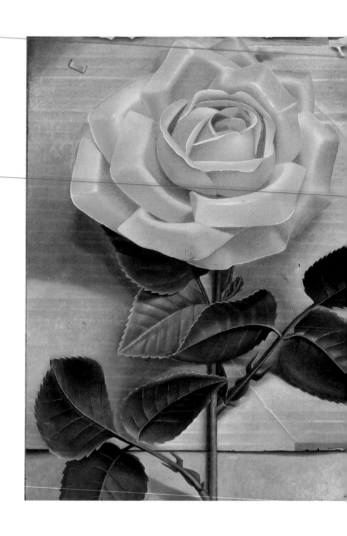

Doll, 1971,
acrylic on canvas,
162 x 411 cm.

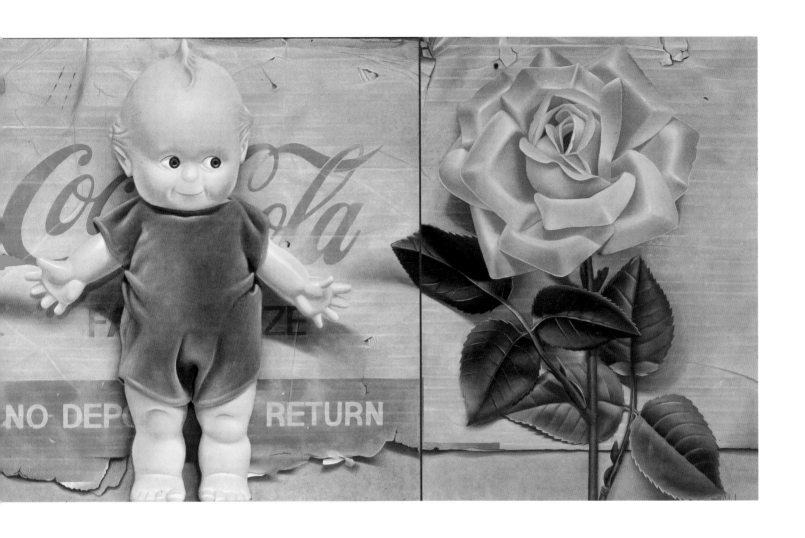

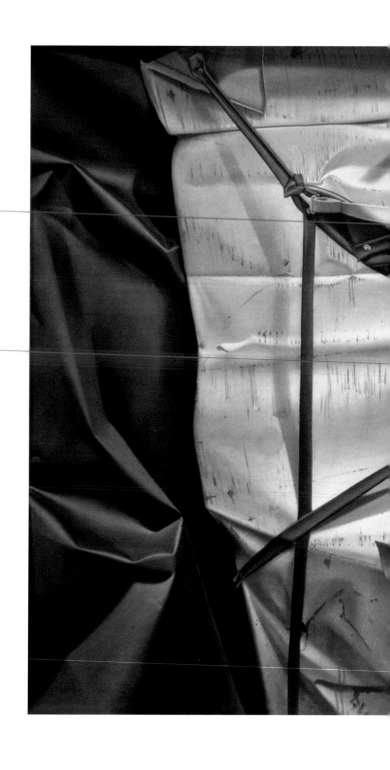

Drum, 1972,
acrylic on canvas,
218 x 406 cm.

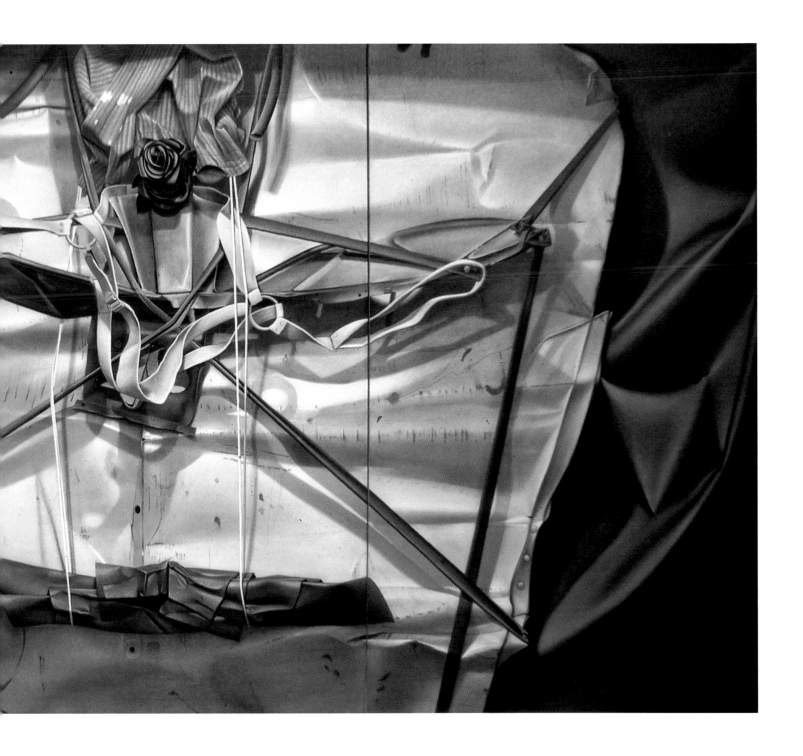

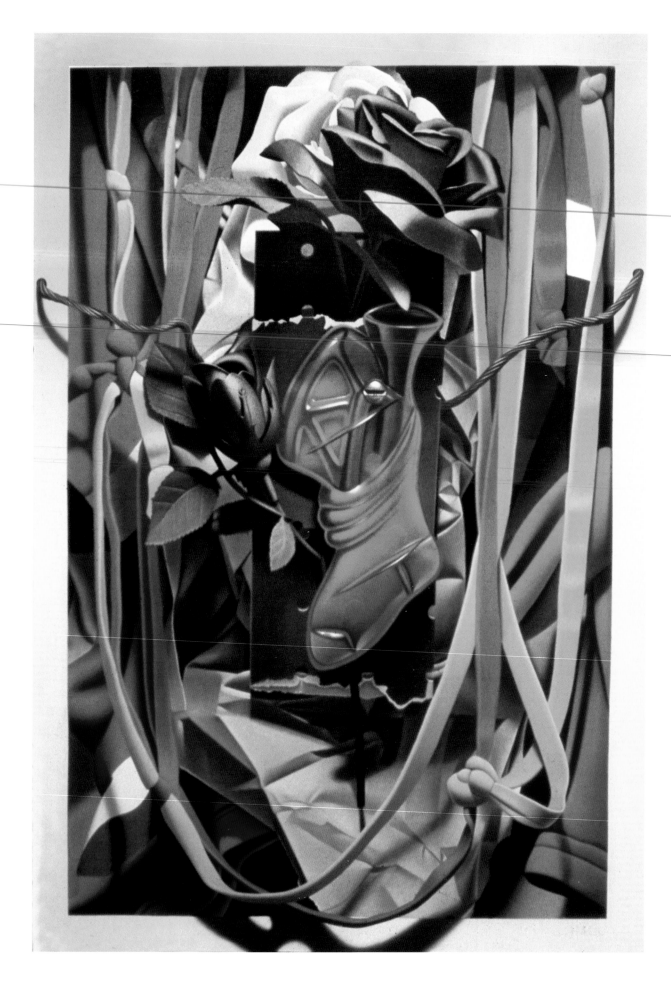

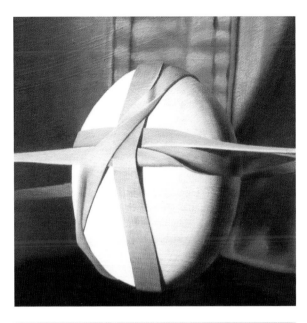

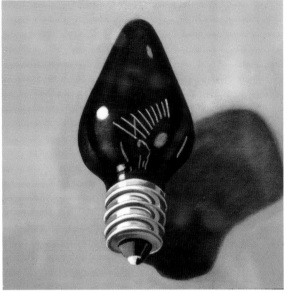

Bondage Egg, 1976,
acrylic on panel,
18 x 18 cm.

Christmas Light, 1976,
acrylic on panel,
18 x 18 cm.

Pilot, 1976,
acrylic on canvas,
223 x 155 cm.

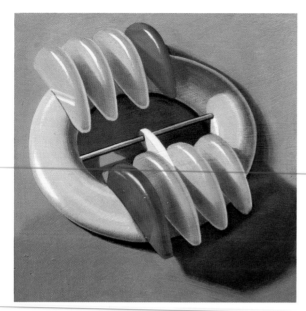

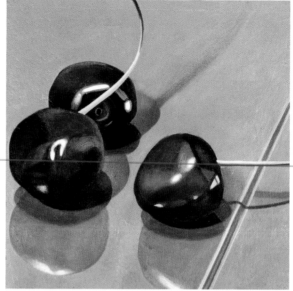

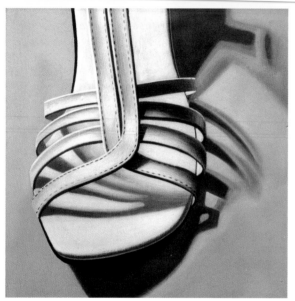

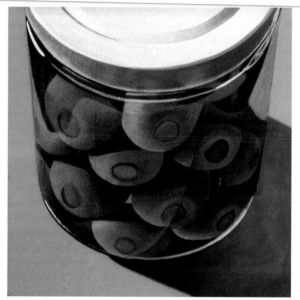

Art Deco Buckle, 1976,
acrylic on canvas,
18 x 18 cm.

Cherries, 1976,
acrylic on canvas,
18 x 18 cm.

White Shoe, 1976,
acrylic on canvas,
18 x 18 cm.

Martini Olives, 1976,
acrylic on canvas,
18 x 18 cm.

In the summer of 1976 the Halls made an extended visit to California, where no dedicated studio space was available. Adapting to this situation, Hall decided to create a series of tiny paintings (they are all 18 by 18 centimetres in size), each depicting a domestic subject. He set himself the project of making one complete painting in a single day. This untitled series portrayed each item—a plate of cookies, a folded pair of jeans, a Christmas tree light bulb, for instance—as sitting in a normal, receding space. This group of paintings began Hall's predilection for the square format, which he has since used so often (though not exclusively), but did not bring an end to his painting of junk and debris.

In the following year, 1977, the Halls made a trip to England, Holland, and France to tour museums, and in 1979, John Hall spent a year in New York, working at the Canada Council's PS1 studio. It was here that he began to first use a camera as an aid and tool in his painting, beginning with shooting in black and white and making 20 by 25 centimetre-sized prints that he used as an additional visual resource when formulating the tonal ranges in the constructed maquettes he had begun using for his still life paintings. He found that if he kept the overall number of tonal ranges reduced it increased the feeling of drama in his paintings. The camera does this—pushes grey tones toward either black or white, rather than conveying a huge range of greys—whereas the human eye does not. He continued to work in a large scale and with discarded junk as his subjects. His skill at *trompe l'oeil* continued to grow. Hall's work began to be included in various group exhibitions and in 1979 he was given a solo exhibition at the National Gallery of Canada, which subsequently went on a national tour.

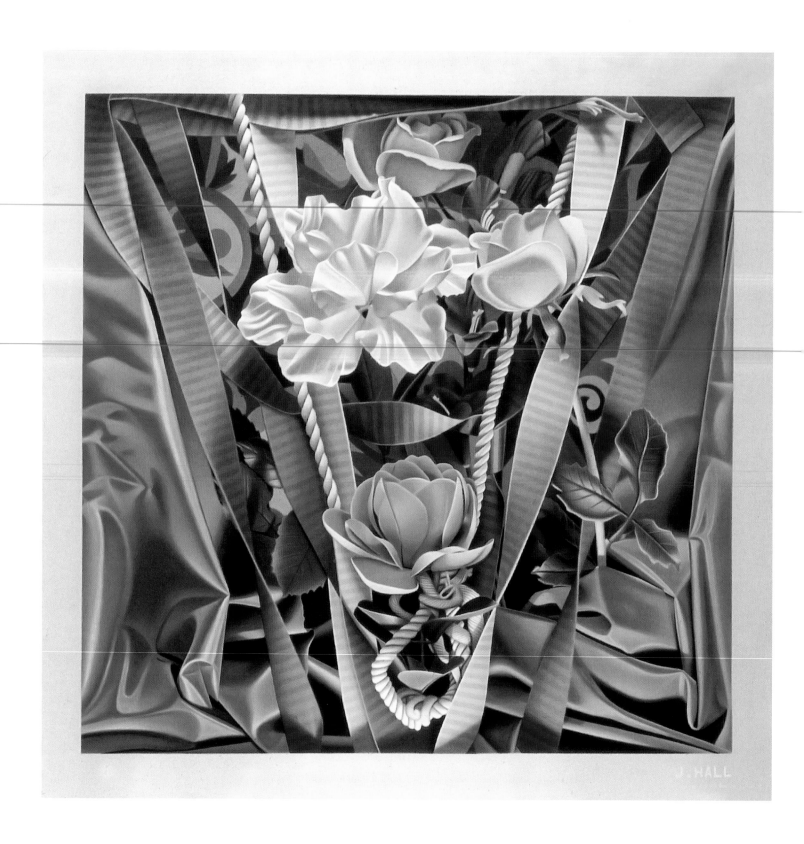

Grace, 1976,
acrylic on canvas,
157 x 157 cm.

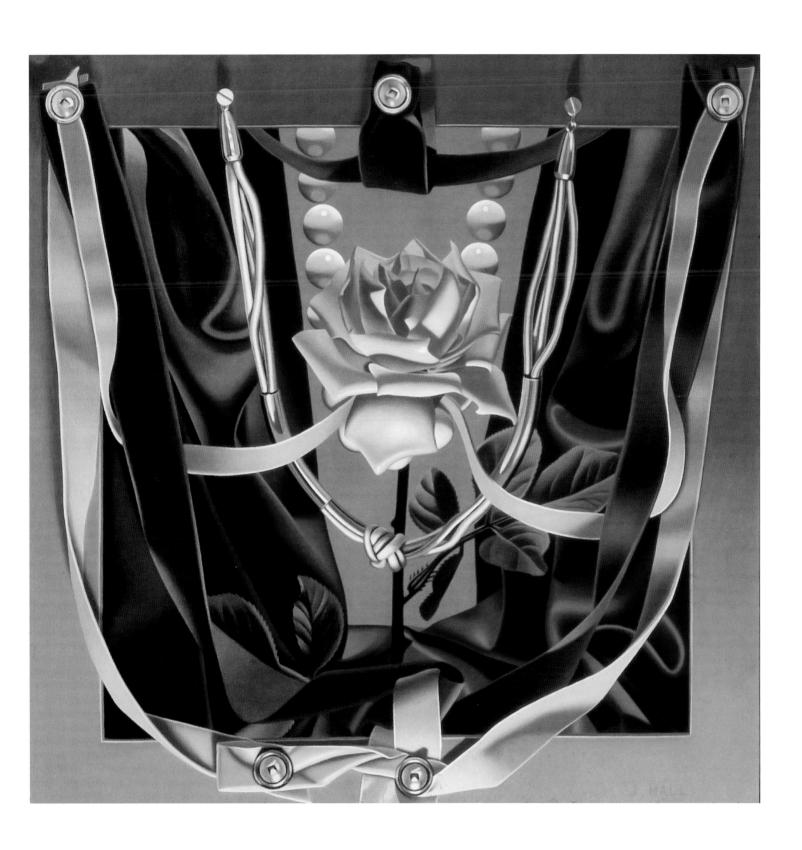

Tango, 1977,
acrylic on canvas,
157 x 157 cm.

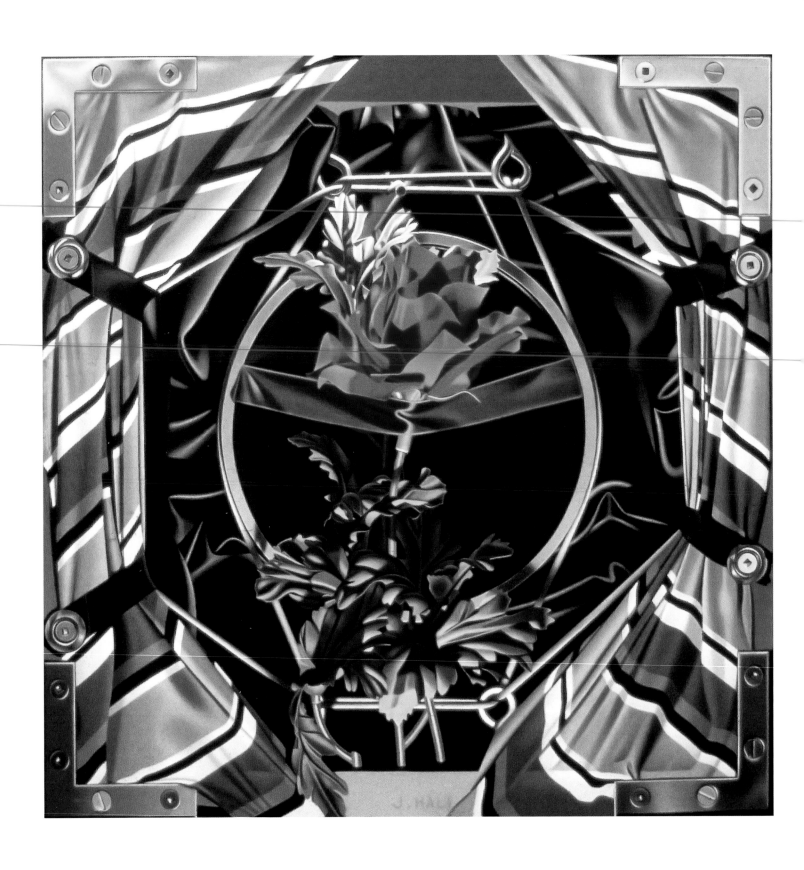

Hitter, 1978,
acrylic on canvas,
152 x 152 cm.

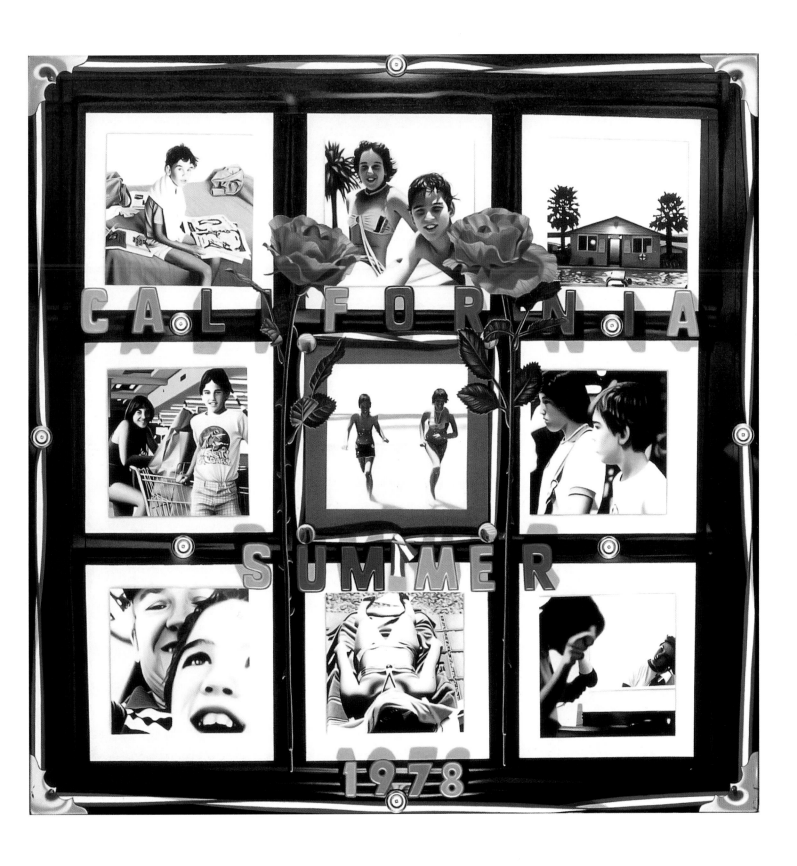

California Summer, 1979,
acrylic on canvas,
152 x 152 cm.

1980s

The decade of the 1980s began for Hall living back in Calgary after his year in New York. In 1980 his work was taken on by the Wynick/Tuck Gallery in Toronto, with whom he continued to work until 2009. It was in the 1980s that his work came into its own and Hall began to hit his mature stride as an artist. His initial work in this decade was his *Tourist* series, painted from 1980 to 1982. The series comprises ten works, all 61 by 61 cm in size. Partly inspired by his own travels as a tourist, the paintings explored the phenomenon of souvenirs and mementoes standing in for our travel experiences. It seems that often our shopping for little geegaws to take home overrides or even supplants our actual experiencing of and engagement with a new place or big tourist attraction. Most of the *Tourist* paintings are set up a bit like a three-dimensional pop-up greeting card or children's book, opening toward the viewer with various little items extending into the foreground, in some cases even further than that—by *trompe-l'oeil* means (as seen in Baroque painting), such as thrusting diagonals and painted cast shadows. These pieces seem to sparkle like jewels, as though they are spot-lit, and tempt us to reach out and touch the closest items, which seem to be extending from the picture plane into our own space.

To make the *Tourist* paintings, Hall assembled and set up the arrangements of stuff, photographed them, then dismantled them, and finally proceeded to paint from 20-by-25.4-centimetre-sized printed colour photographs. The paintings are extremely visually complex and dense. One might well imagine they had been painted by a different artist than the author of the 18-by-18 centimetre single-subject works of only four years earlier. Perhaps fuelled by all the art he had seen during his 1979 year in New York, Hall had upped his game.

John Hall in his Calgary
studio, 1984.
Photo: Don Corman.

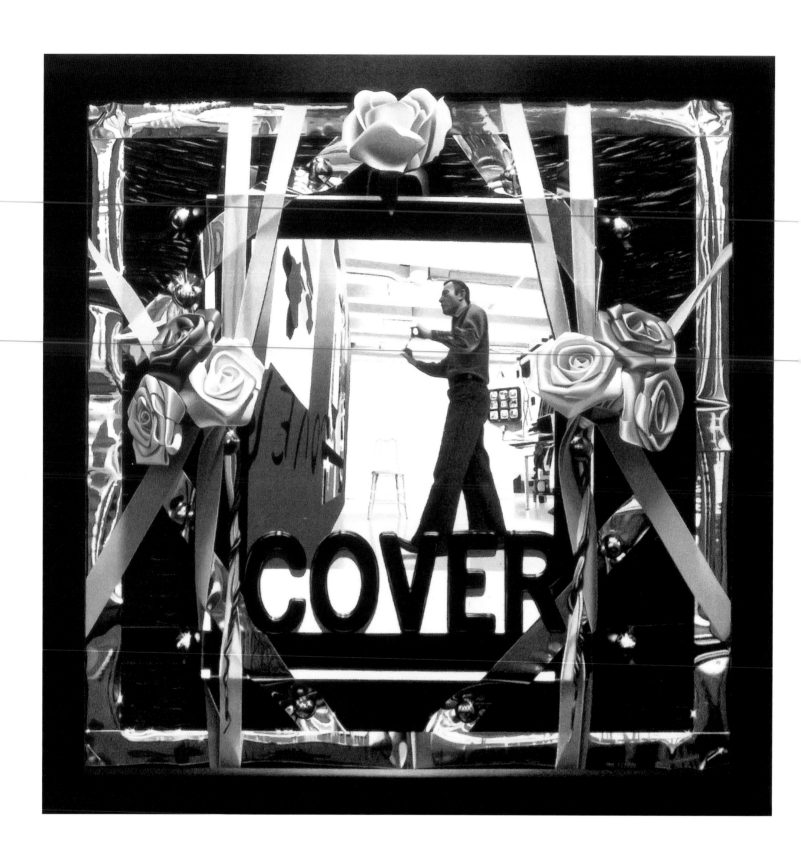

Cover, 1980,
acrylic on canvas,
112 x 112 cm.

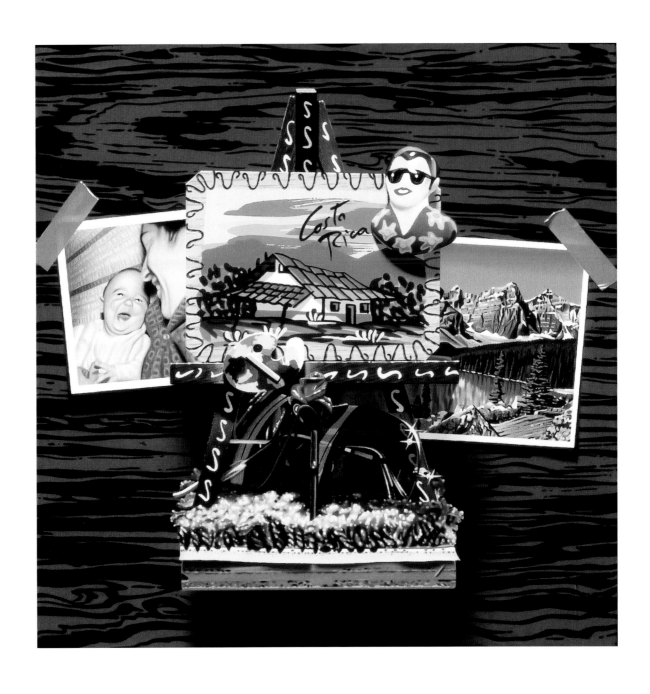

Tourist IV, 1980,
acrylic on canvas,
61 x 61 cm.

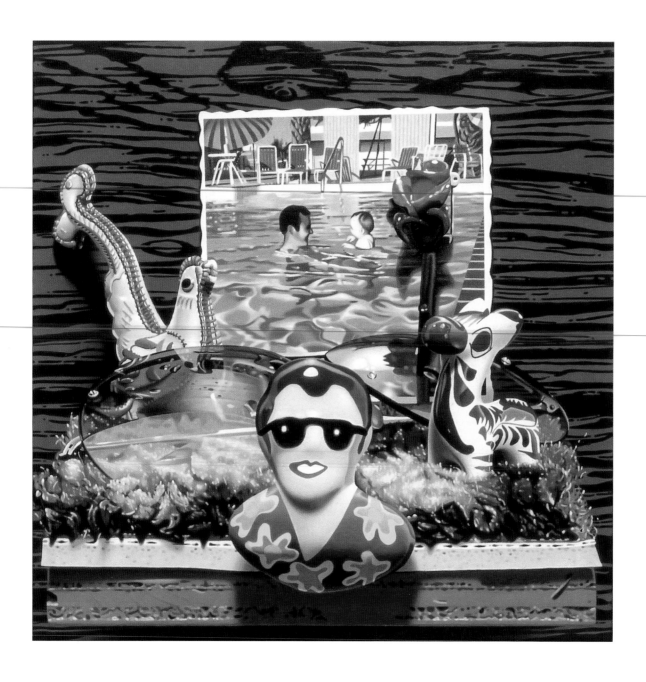

Tourist III, 1980,
acrylic on canvas,
61 x 61 cm.

Tourist VII, 1980,
acrylic on canvas,
61 x 61 cm.

The artist's next series, begun when the *Tourist* works were part way along, was his 1981–1982 *Toys* series, also consisting of ten paintings, each 61-by-61 centimetres in size, but this time of single subjects again. The toys chosen to be painted were mostly plastic in bright colours (understandable, given that this is how toys are often made) and each was placed on a sheet of coloured construction paper for photographing and then painting. Hall's interest in the strong, gleaming highlights on the toys' surfaces is highly evident. But long-time writer on his work, the Calgary-based critic Nancy Tousley, astutely pointed out that most of the ten toys chosen would be menacing or dangerous items were they the real adult versions and not childrens' toys (hand gun, fighter plane, a snake, a pair of handcuffs, for example).[3] Hall was not consciously intending any message by these works, and maybe these were just the toys that attracted him in the store. But perhaps his unconscious was at work and was striving to imbue this series with a darker subtext.

In 1984 Hall made a group of small paintings with subjects derived from a visit to Mexico. Mexican-themed works would become part of his production for several years, especially during the time he lived there for half of each year, from 1988 to 1999. The paintings from 1984 were square in format and usually depicted a single item, often a touristy find from the local street market. Later in 1984 he produced a few larger Mexican-themed works that had arrangements of multiple objects.

These paintings of grouped objects fed into Hall's subsequent series of works begun in the mid 1980s that is still on-going, and for which he became widely known, his *Still Life Portrait* works. To make these paintings Hall invited friends and colleagues to select and lend him some of their personal possessions that they felt accurately represented themselves. The *Still Life Portraits* are all in a square format, and most in a 152 by 152 centimetre size. Hall would make arrangements of the 'sitter's' stuff, light and photograph the still life, and then paint from the colour photographs. At some later point in the 1980s, he began shooting 35 mm slides and then projecting these onto the canvases to paint. Also, he began working with an air brush and would mask off some areas of the canvas with white paper while spraying, so that he could no longer see the painting's entire surface for much of the time as he worked on it. This method took him quite a distance from his painted-from-life giant early canvases, and into a completely other realm of working with his subjects and with photography. The *Still Life Portraits* have terrific gusto and bravura. They are eye-poppingly colourful and bright, and are brimming with detail. In some cases Hall began inserting backgrounds that were colourful Kodak-esque skies, often inspired by magazine advertisements. These tend to give a nod to the increasing role that photography was having in his painting practice, and also nudge us to consider what we are looking at when viewing Hall's realist works—what is the reality he is painting? With the so-called New Realism on the wane in terms of avant-garde art modes and trends, the *Still Life Portraits* could not be considered cutting edge, the way Hall's earlier giant "garbage" paintings actually had been. But there was a wonderful context for Hall's *Still Life Portraits* in the city of Calgary—that pervasive Calgary funk aesthetic that permeated so much of the visual arts in that city during this time period. Hall was not the odd-man-out in his own city, far from it, and he had the respect of his peers and a growing group of collectors as well.

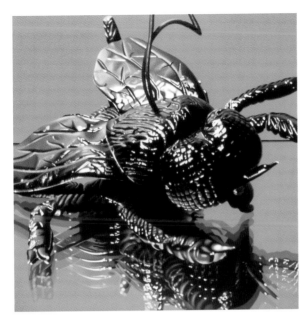

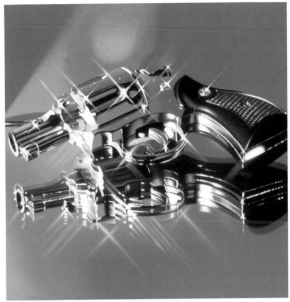

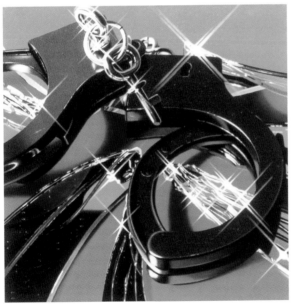

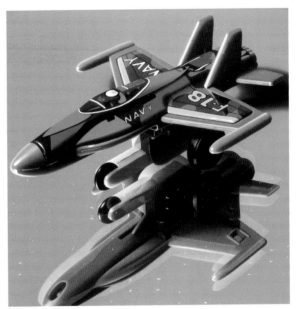

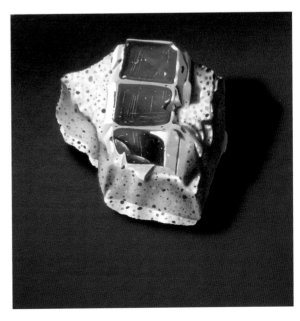

Rubber Fly, 1982,
acrylic on canvas,
61 x 61 cm.

Handcuffs, 1982,
acrylic on canvas,
61 x 61 cm.

Plastic Pistol, 1982,
acrylic on canvas,
61 x 61 cm.

Navy F18, 1982,
acrylic on canvas,
61 x 61 cm.

Mosaic Fragment, 1984,
acrylic on canvas,
24 x 24 cm.

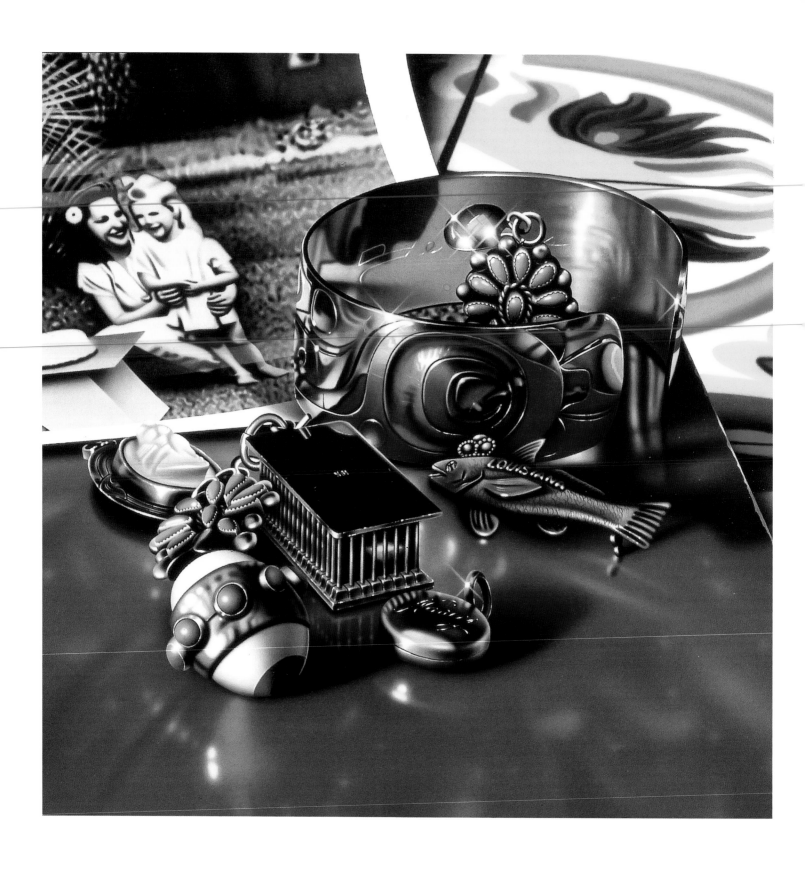

Nancy, 1985,
acrylic on canvas,
152 x 152 cm.

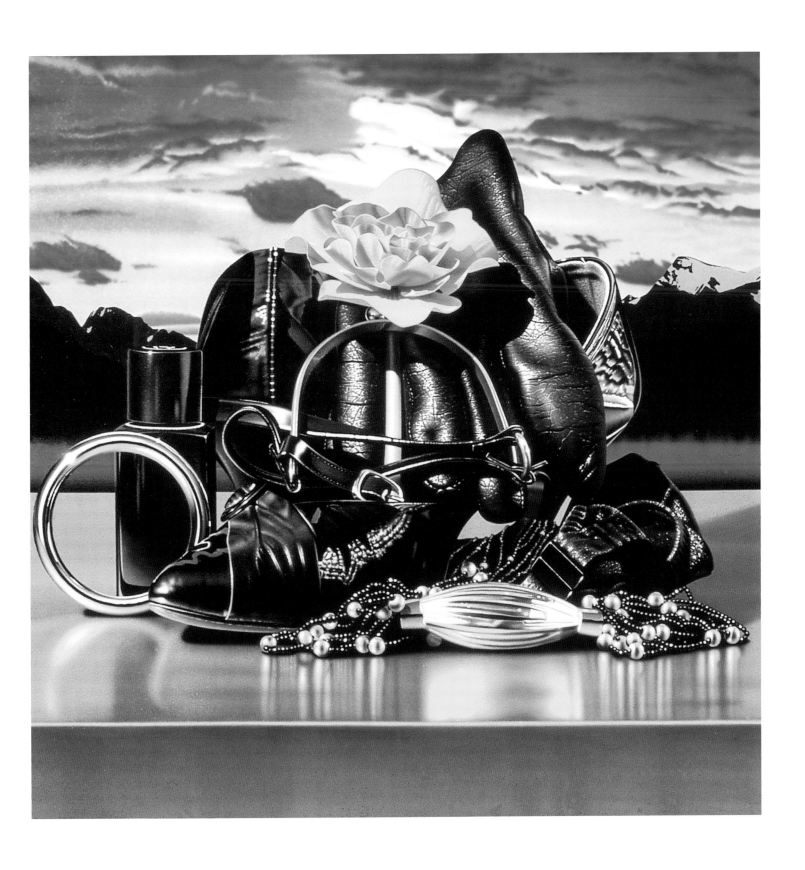

Indigo, 1986,
acrylic on canvas,
152 x 152 cm.

In 1986 Hall had a three-month-long sojourn at Banff, Alberta, working in one of the Leighton Artists' Colony studios at the Banff Centre. He completed three paintings there, having set up the still lifes and photographed them before leaving Calgary. One of these is a still life portrait of his wife—*Indigo* depicts Joice M Hall's shoes and jewellery sitting on a shiny golden platform, set against a silhouetted mountain landscape with a mauve and blue sunset behind. It is an unusual manner for an artist to use to depict his wife, but by this time John Hall's painting had become more and more unusual.

John Hall was fortunate in having lived in San Miguel, Mexico for half of each year for a decade in a time when the town was still relatively unspoiled. A separate essay in this publication by his fellow artist and colleague Alexandra Haeseker will discuss his Mexican paintings in depth, including a collaborative series of paintings they did together (alternating their spurts of painting on each canvas) called *Pendulum/ Pendula*, which has been exhibited widely. In 1988 he began a series of 61-by-61-centimetre-sized works that were of single Mexican objects, often ceramic or clay figurines, depicted in minimalist desert locations with lurid photographic sunsets behind. Perhaps these paintings formed a way "in" for Hall, to beginning to understand his new environment, which was a completely different culture from his own. In her important and insightful 1989 text on Hall, Nancy Tousley wrote that "[Realism] has become less a way of knowing the world than a way of thinking about the world...."[4] and these paintings could be seen as Hall's visual thinking about his new life in Mexico.

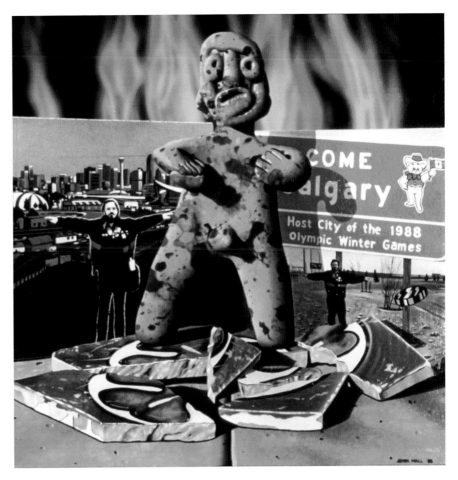

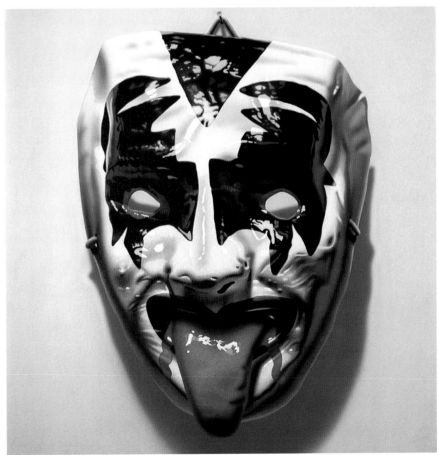

Zacatecas, 1988,
acrylic on canvas,
61 x 61 cm.

Campeche, 1988,
acrylic on canvas,
61 x 61 cm.

The artist's last painting of the 1980s was a *Still Life Portrait* of his artist colleague ManWoman (1938–2013), called *Angel*. A central ceramic Buddha that is flanked by a skull and two small pendant skeletons sits behind a quilted smiling heart with wings. Born Patrick Kemball, the artist ManWoman had been a student with Hall at the Alberta College of Art and they had remained in touch. He was a mystic and visionary from the Kootenays region of British Columbia and a fairly well known artist. It is now left to viewer speculation as to the significance of the objects he lent Hall to paint his *Still Life Portrait*.

Hall's *Still Life Portraits* were featured in a solo touring show organized in 1989 by the Agnes Etherington Art Centre at Queen's University in Kingston. This show and his regular exhibitions at the Wynick/Tuck Gallery in Toronto helped in winning him a national reputation, reception, and audience. He had managed to carve out a niche for himself in the Canadian art world of the day—his work was intriguing and utterly unique.

John Hall at the Leighton Artists' Colony at the Banff Centre, Banff, Alberta, in front of a work he was producing for a commission that was later cancelled, at left, beside him left to right are fellow Calgarian artists Mark Dicey, Don Mabie and Wendy Toogood, c 1989.

Flame, 1988,
acrylic on canvas,
152 x 152 cm.

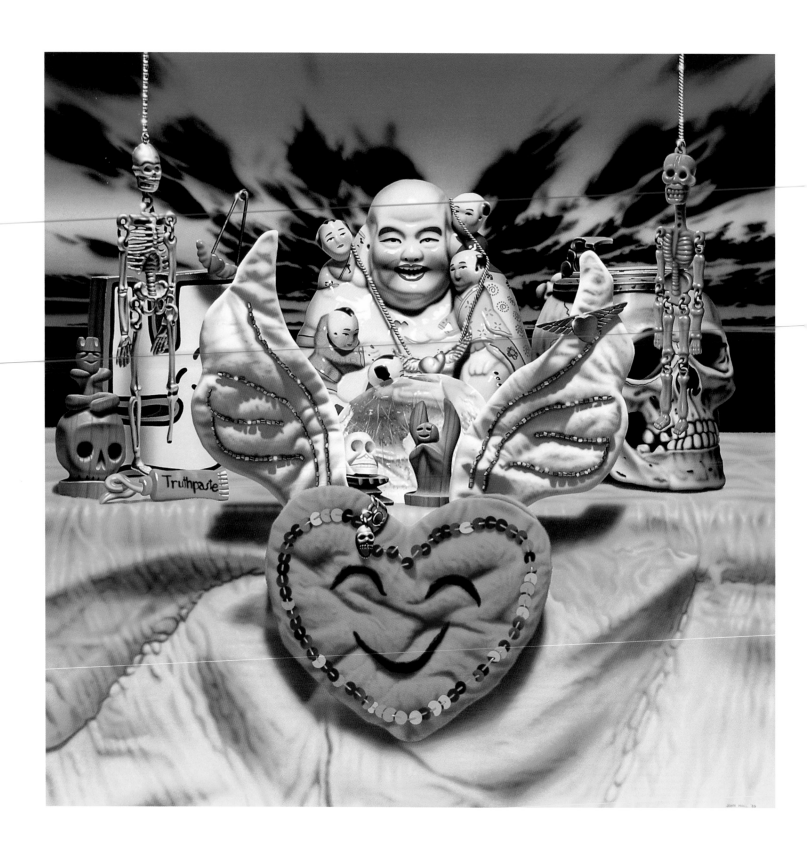

Angel, 1989,
acrylic on canvas,
152 x 152 cm.

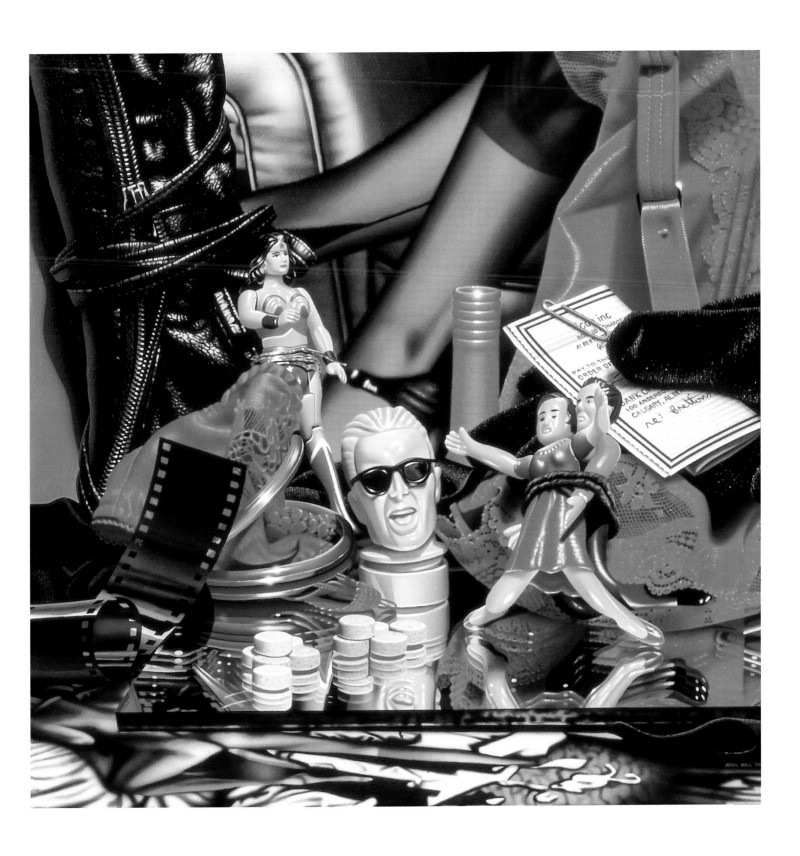

Icon, 1990,
acrylic on canvas,
91 x 91 cm.

1990s

John Hall's paintings from the 1990s focused on Mexican objects (such as figurines or masks, or household subjects, such as dishes loaded into a dishwasher in the kitchen, which he titled *Studio Series*, *Bedroom Series*, and *Kitchen Series*, just to identify them. He also worked on the 12 *Pendulum/Pendula* works with Alexandra Haeseker. Another of his Mexican series was called *La Disposicion del Mercado*, which consisted of eleven various sized canvases all depicting masses of small objects of the street market variety, arranged amongst fruits and vegetables, some cut open as though ready for eating. The series title roughly translates into "The Market Arrangement". These, along with others of Hall's Mexican themed works and a selection of *Still Life Portraits* and other paintings, were included in a solo show called Traza de Evidencia [Trail of Evidence] held in Mexico City at the Museo de Arte Moderno in 1993.[5] A strange but fascinating text was written on these paintings for the exhibition catalogue by Hall's Calgary artist colleague and neighbour in San Miguel, Derek Michael Besant.[6] Besant states that he thinks Hall has been miscast as a realist—mis-categorized. I imagine Besant means by this that we need to look beyond Hall's realism to penetrate and extract meaning from his work—that the realism *per se* is not necessarily the point. Later in his text Besant writes that Hall's paintings are "… arenas for him to better place himself and his relationship to the objects portrayed. The painting, then, is the go-between, somewhere between image and meaning, word and definition, ego and conceptual language."[7] The notion of Hall's paintings existing in a borderland territory that is betwixt and between, a kind of interstice between the artist and given, concrete notions is fascinating. It certainly prods a viewer to consider more deeply just what s/he is looking at when presented with one of Hall's paintings.

Hall's domestic-themed paintings from the mid 1990s were all 15 by 23 centimetres (sometimes flipped to 23 by 15) in size, and painted on hardboard. The works appear casual—just slices of daily life—small scenes of domestic objects or materials depicted just as they just happened to sit on the table, the shelf, or in the fridge. Each composition was closely cropped and viewed at close range. It was mid-way through painting this series of work that Hall began shooting with a digital camera and then manipulating the image in Photoshop before making a colour print to paint from. This aspect was to become increasingly important in his projects.

One may well wonder in the case of the *Studio*, *Bedroom*, and *Kitchen* series, whether the tidbits of domestic interiors are just banal subjects, or do they act as mute markers, pointing to something deeper, some grasp of the meaning that can lurk in our quotidian lives? Whatever the case I feel convinced it would be a mistake to take these works only at their face value. One may call to mind Virginia Woolf's passage from *To the Lighthouse*: "What is the meaning of life? That was all—a simple question; one that tended to close in on one with years, the great revelation had never come. The great revelation perhaps never did come. Instead, there were little daily miracles, illuminations, matches struck unexpectedly in the dark…."

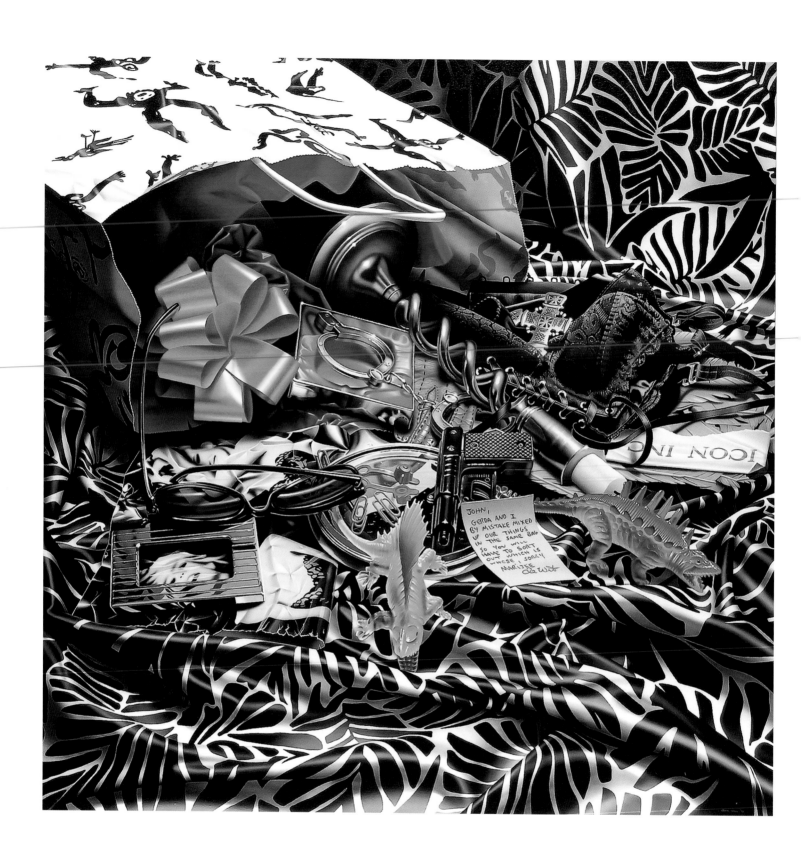

Gerda & Marijke, 1991,
acrylic on canvas,
152 x 152 cm.

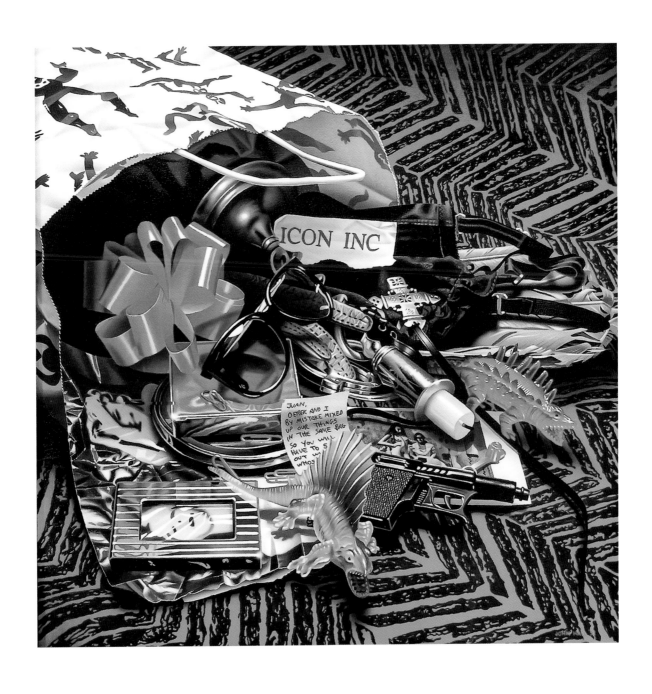

Tattoo, 1991,
acrylic on canvas,
61 x 61 cm.

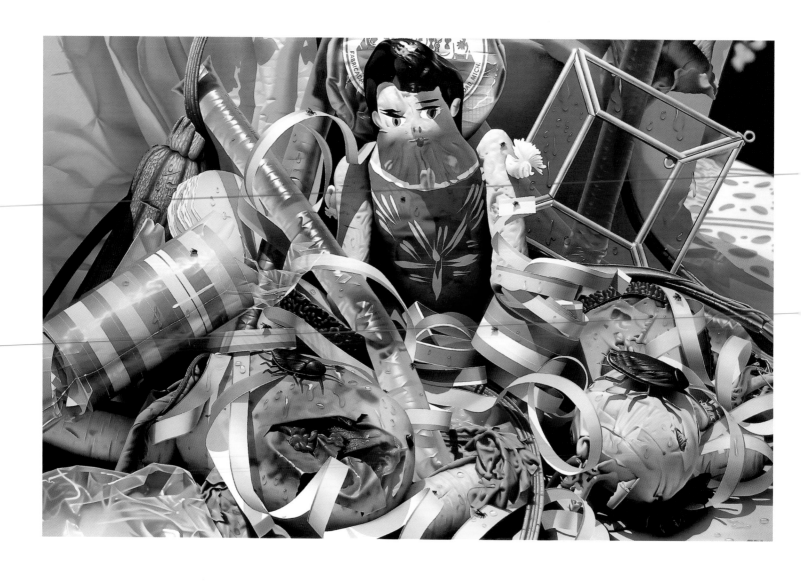

Muñeca, 1992,
acrylic on canvas,
152 x 228 cm.

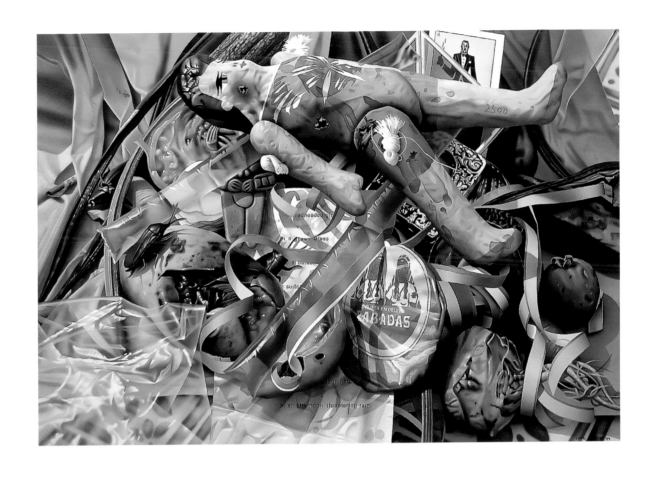

Rain, 1994-2004,
acrylic on canvas,
63 x 94 cm.

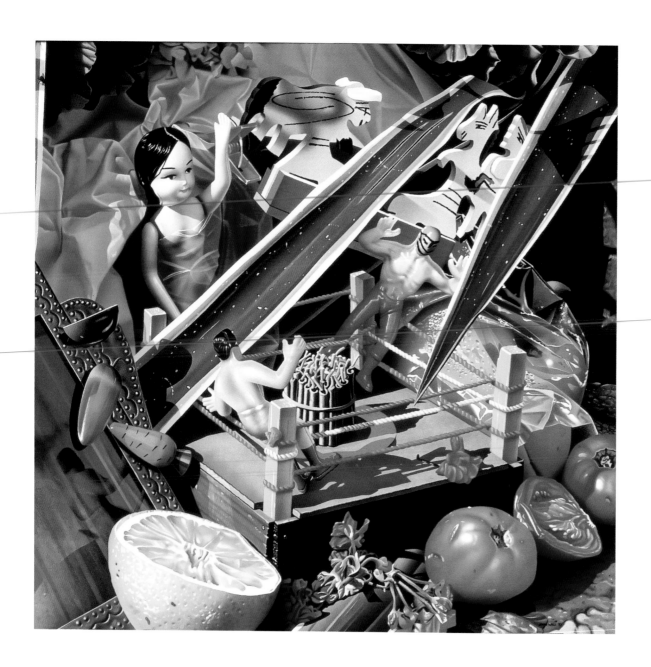

Calypso Warrior, 1994,
acrylic on canvas,
91 x 91 cm.

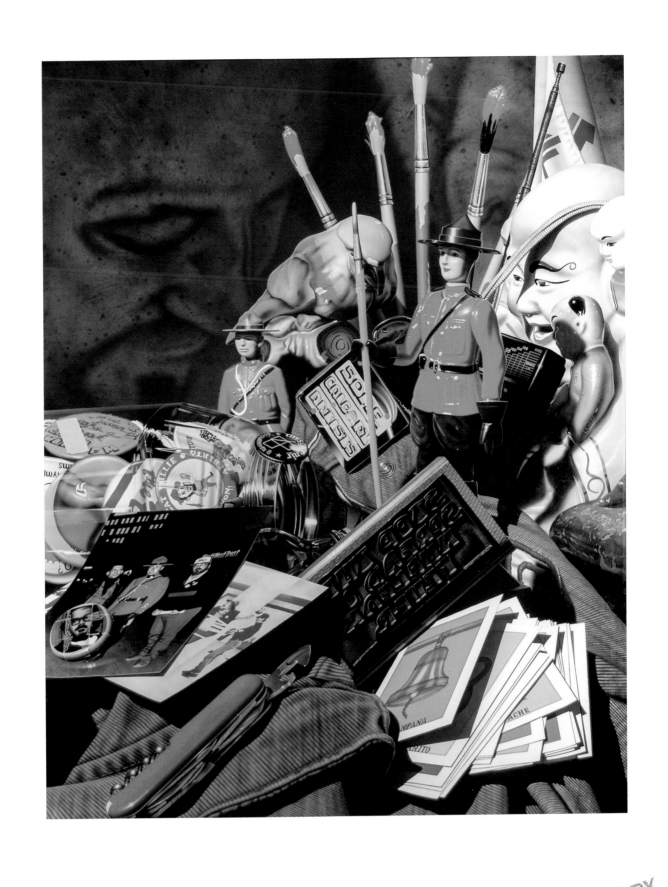

Nuclear Fever, 1994,
acrylic on canvas,
213 x 168 cm.

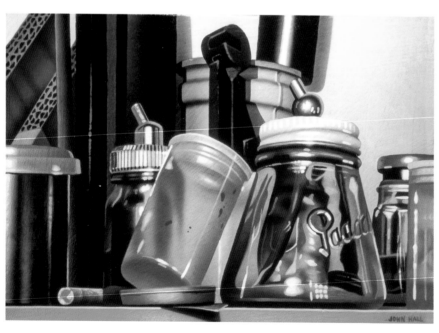

K6, 1995,
acrylic on hardboard,
23 x 15 cm.

S4, 1995,
acrylic on hardboard,
15 x 23 cm.

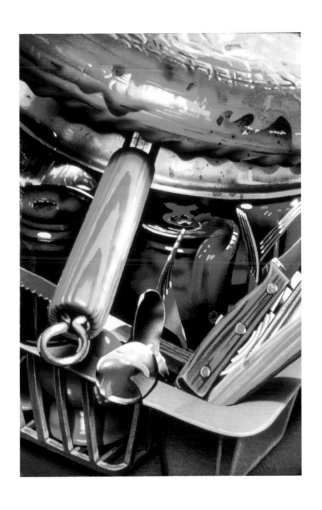

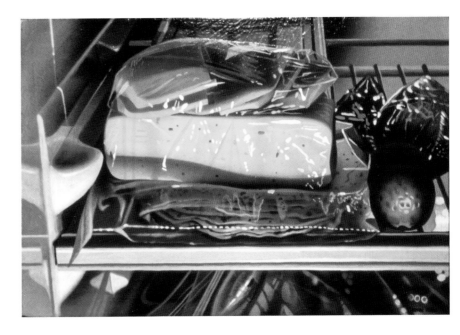

K7, 1995,
acrylic on panel,
23 x 15 cm.

K5, 1995,
acrylic on hardboard,
15 x 23 cm.

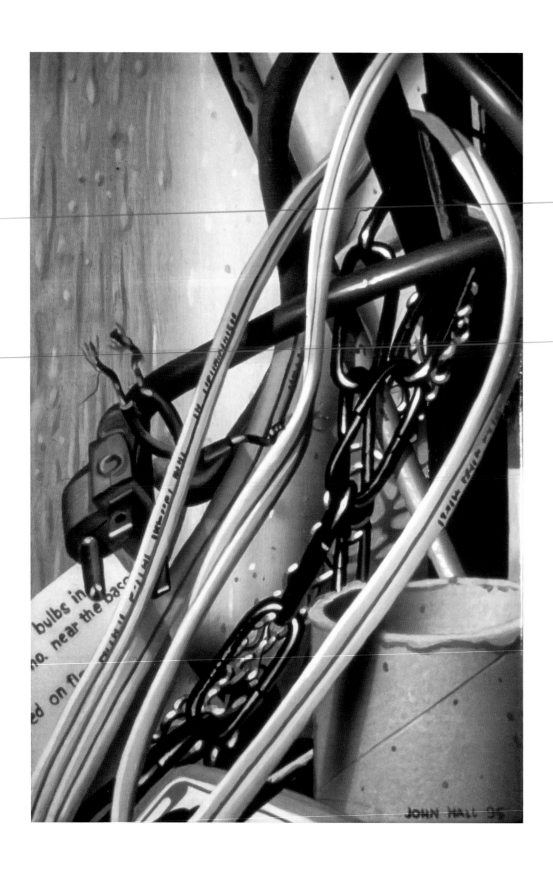

S1, 1995,
acrylic on panel,
23 x 15 cm.

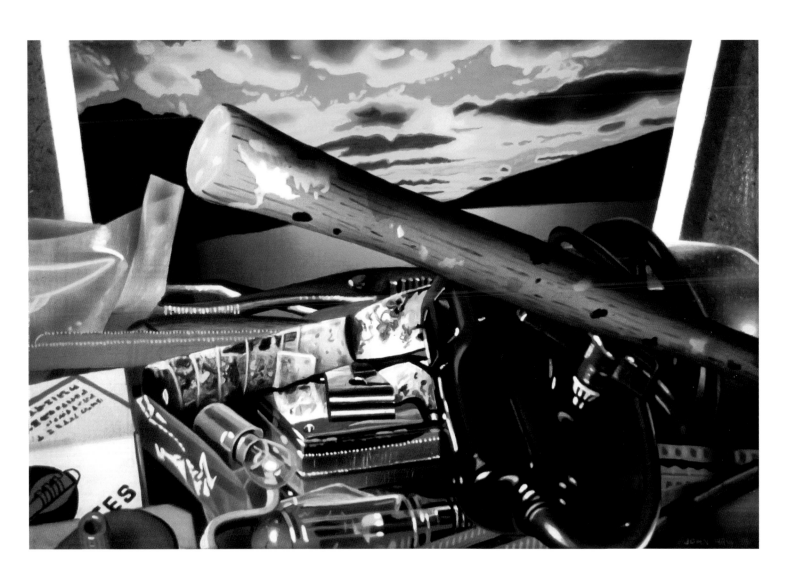

S5, 1995,
acrylic on panel,
15 x 23 cm.

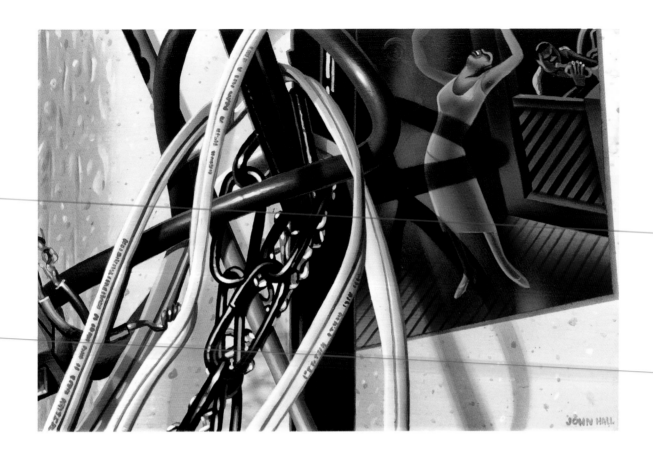

Rhapsody formerly *S6*, 1995,
acrylic on panel,
15 x 23 cm.

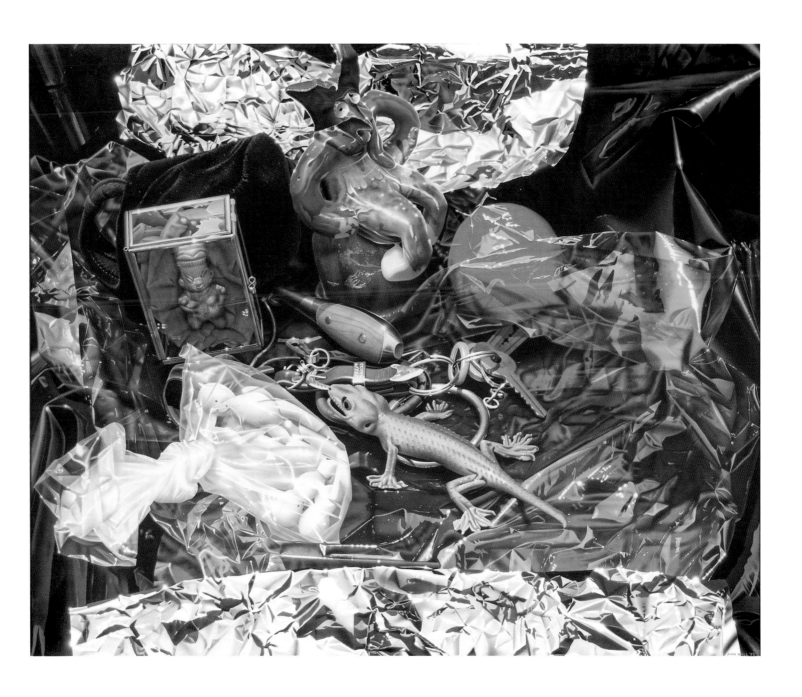

Scar, 1995,
acrylic on canvas,
152 x 185 cm.

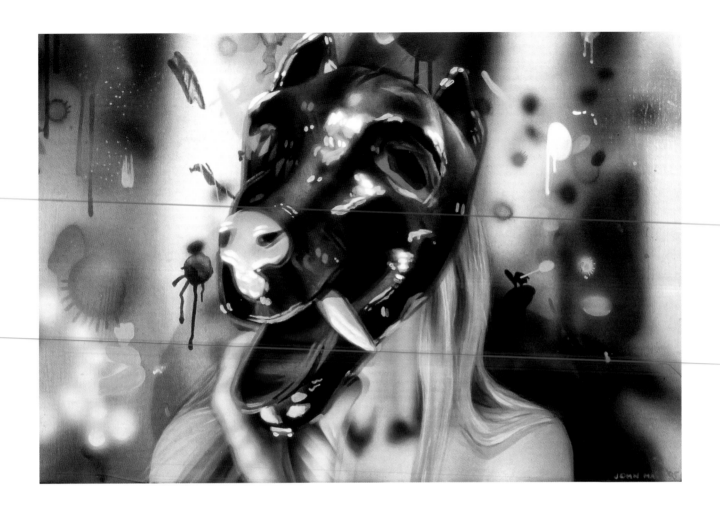

Mask 1, 1995,
acrylic on panel,
15 x 23 cm.

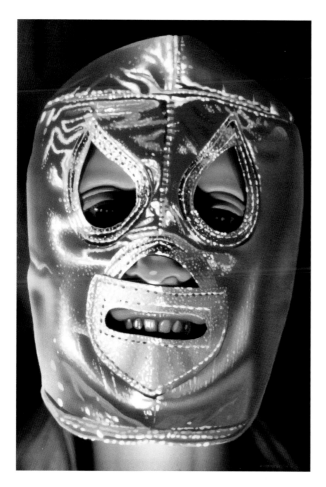

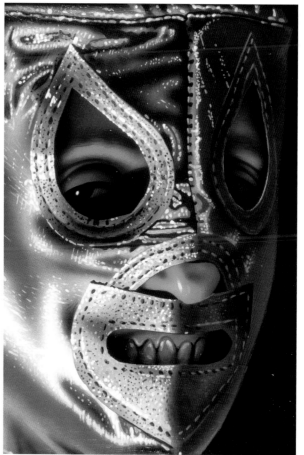

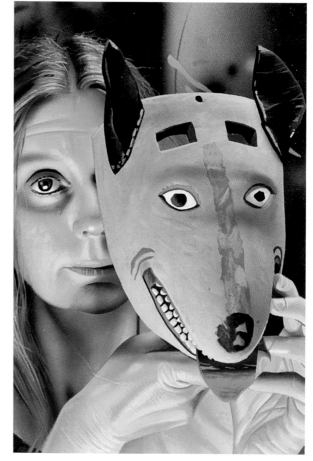

Mask 7, 1995,
acrylic on panel,
23 x 15 cm.

Mask 8, 1995,
acrylic on panel,
23 x 15 cm.

Mask 9, 1995,
acrylic on panel,
23 x 15 cm.

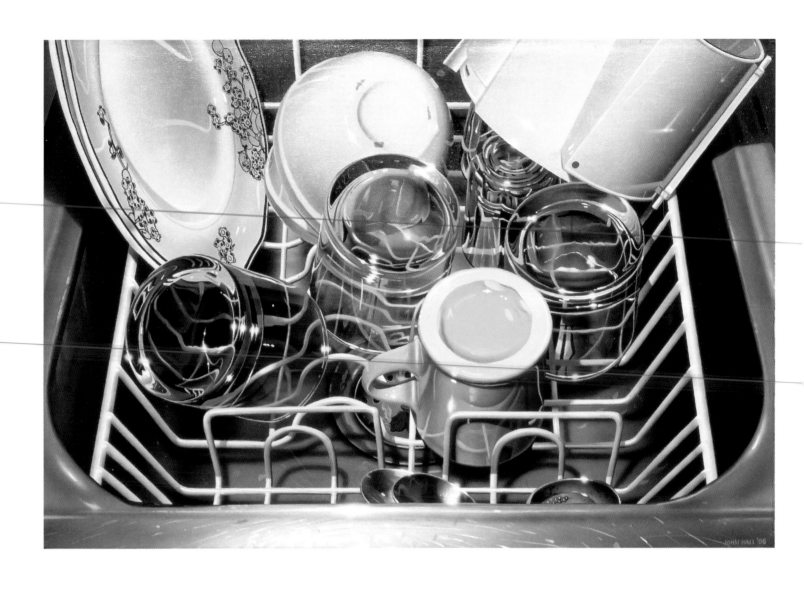

Dishes, 1998,
acrylic on canvas,
45 x 68 cm.

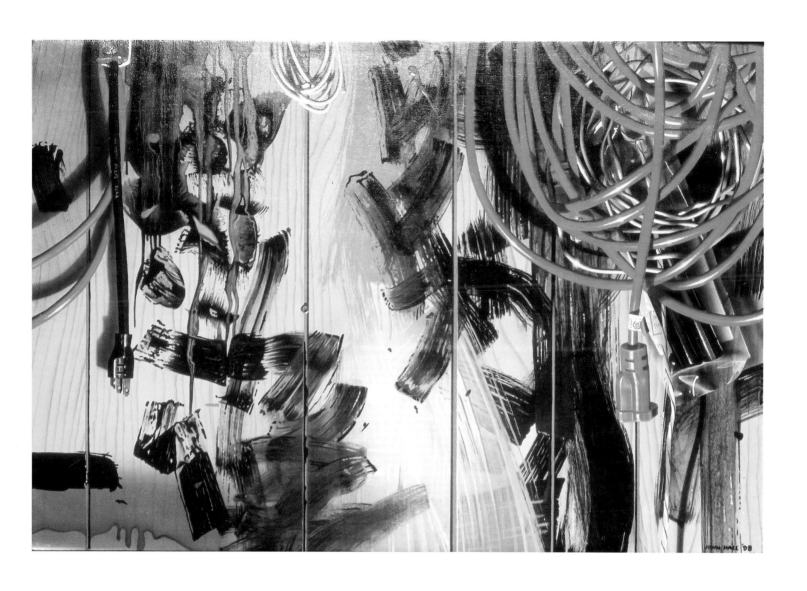

Tar, 1998,
acrylic on canvas,
45 x 68 cm.

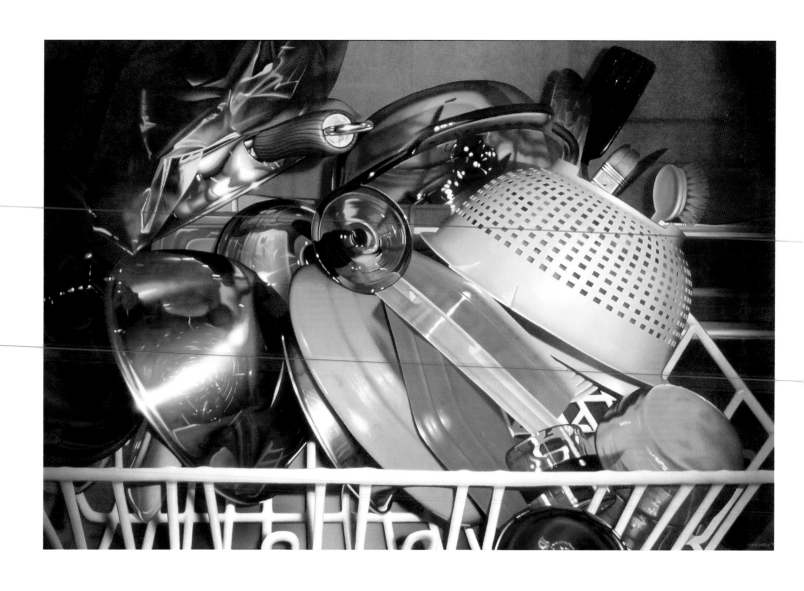

3.02.99, 1999,
acrylic on canvas,
61 x 91 cm.

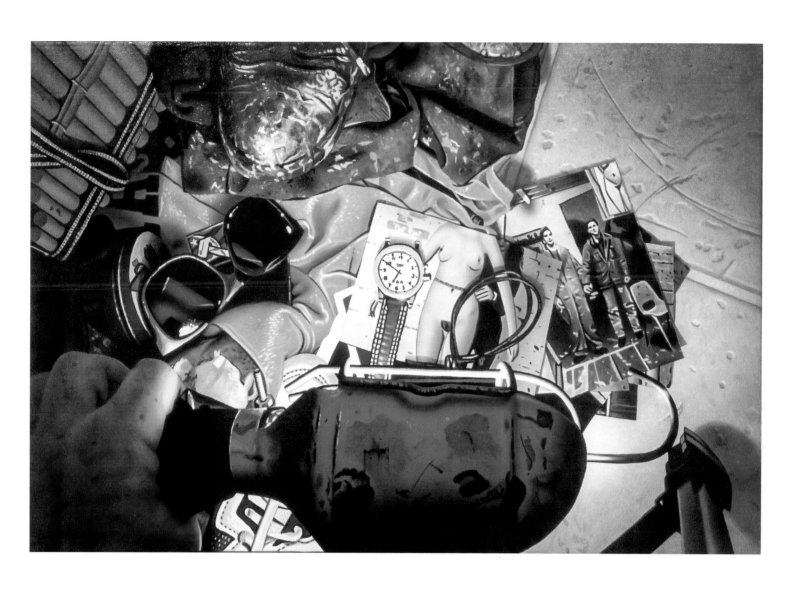

Tape Elena, 2000,
acrylic on canvas,
30 x 45 cm.

John Hall's move from both San Miguel and Calgary to relocate fulltime to Kelowna, British Columbia in 1999 must have been an upheaval, yet he seems to have landed on his feet and did not suffer any lapse in his painting production. His work underwent a change however, shifting from its former funkiness to an almost serene calm and almost spiritual mood. The previous usual density and crowded quality to his compositions seems to have just lifted off with Hall's *Six Stones Series*, begun in 2001. To start with, the items depicted have become far fewer in number. The fourteen works in this series are all rectangular, 61 by 91 centimetres in size, and are zen-like in their calm, especially in contrast with Hall's previous dense and crowded works. The first few *Six Stones* paintings depicted the little stones set on a white ground. There they sit, a gathering of very different small stones: one smooth and round and black, another long and rough and jagged, and so on. In later works, the stones are mixed in with studio implements, such as a roll of green masking tape, and in 2005 Hall created some *Six Stones* paintings in which the stones were set up with small carved stone figurines from Mexico set against a background of aluminum foil that provides a panoply of reflections.

Hall created his fifty-plus-work *Quodlibet* series from 2002 to 2008. Its title is intriguing. I believe Hall heard the word one day on CBC Radio. In English it can mean either a light-hearted medley of texts or tunes, or a point for theological or philosophical discussion. But it is also a Latin word that means "whatever", and I am sure Hall was thinking of this meaning in connection with his choice of painting subjects: whatever—they are not important. With this shrug to his audience, he has depicted such items in his *Quodlibet* series as glass marbles, lollipops, peeled fruits, tape measures, licorice allsorts, coffee mugs, and tea cups. One features a stacked pile of CDs or DVDs, like a contemporary tower of Babel. All the paintings are either 25 by 38 centimetres, or square canvases at 30 by 30 centimetres.

After completing the *Quodlibet* series, Hall began paintings in a group he called *Sweetness and Light*—canvases depicting licorice allsorts, greatly enlarged doughnuts, and chocolates. These paintings have titles that sound as though they were lifted from a vintage Batman comic book: *Jump, Orbit, Snap!, Boom!, Slam!, Krunch!* and *Boing!*, for example. The works are *tours-de-force* of verisimilitude and have a great overall mood of *joie-de-vivre*.

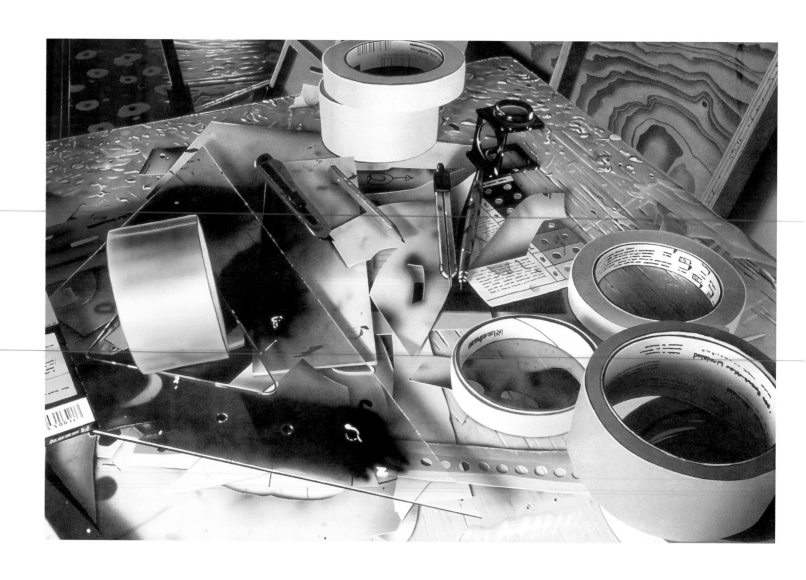

Arrow, 2000,
acrylic on canvas,
61 x 91 cm.

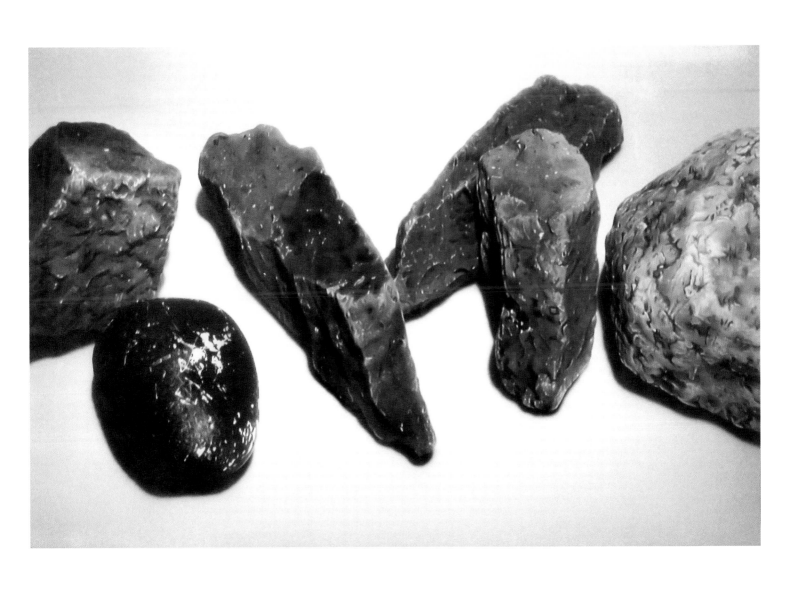

Not Yet, 2001,
acrylic on canvas,
61 x 91 cm.

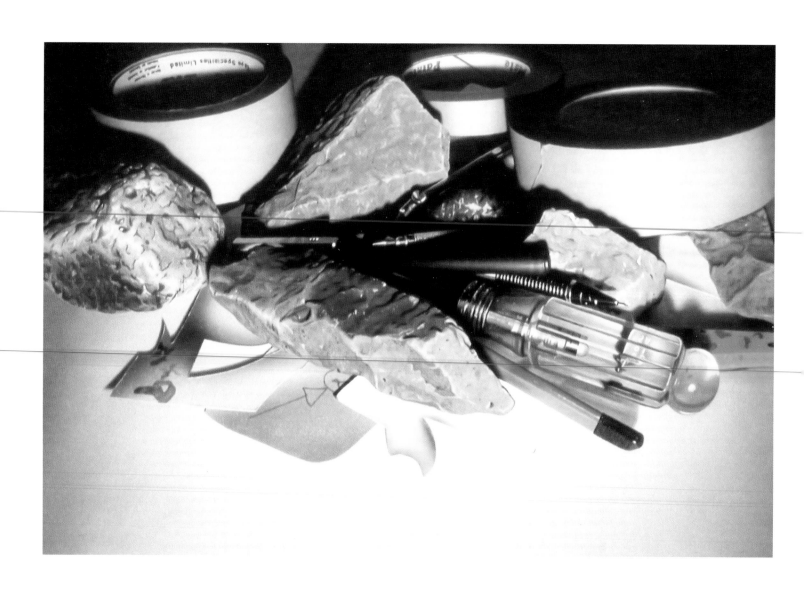

Echo (Six Stones), 2001,
acrylic on canvas,
61 x 91 cm.

Pause (Six Stones), 2001,
acrylic on canvas,
61 x 91 cm.

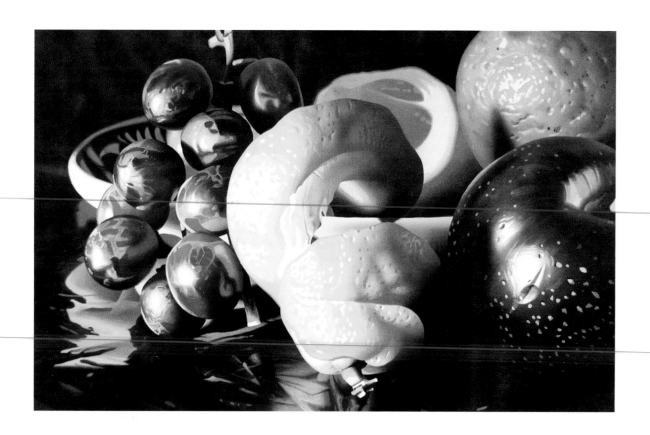

Quodlibet XVI, 2003,
acrylic on canvas,
24 x 39 cm.

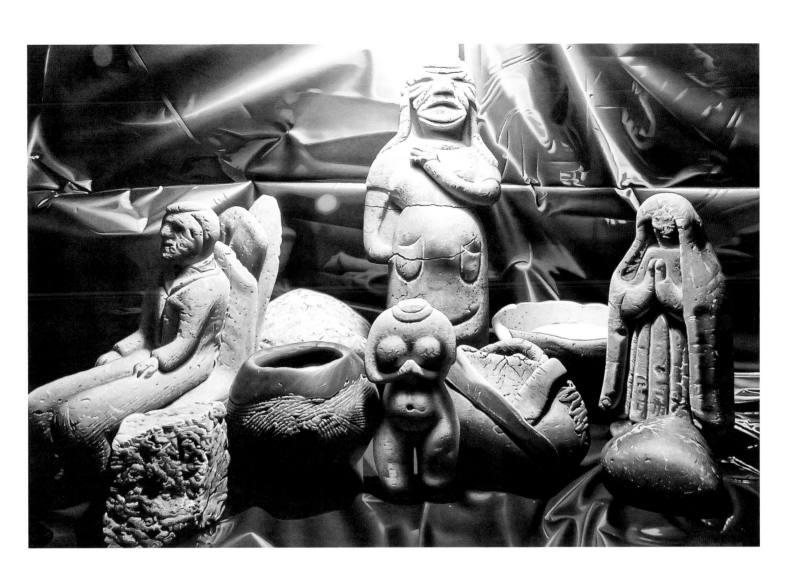

Crack (Six Stones), 2005,
acrylic on canvas,
61 x 91 cm.

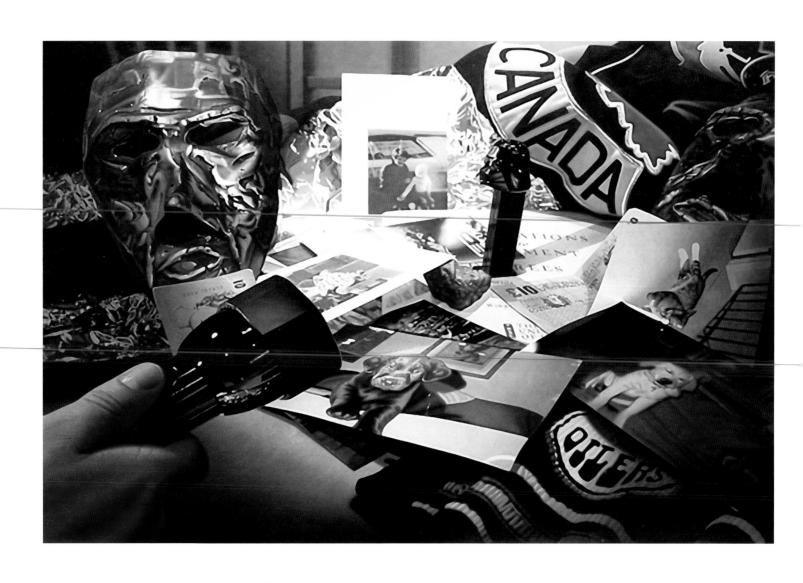

Miracles and Monsters, 2005,
acrylic on canvas,
152 x 229 cm.

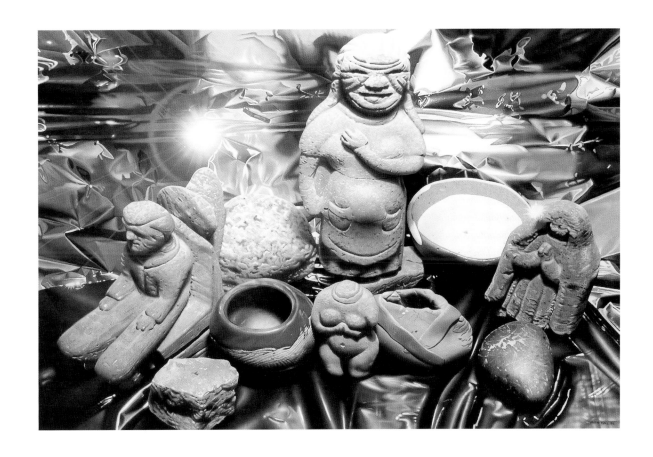

Burst (Six Stones), 2006,
acrylic on canvas,
61 x 91 cm.

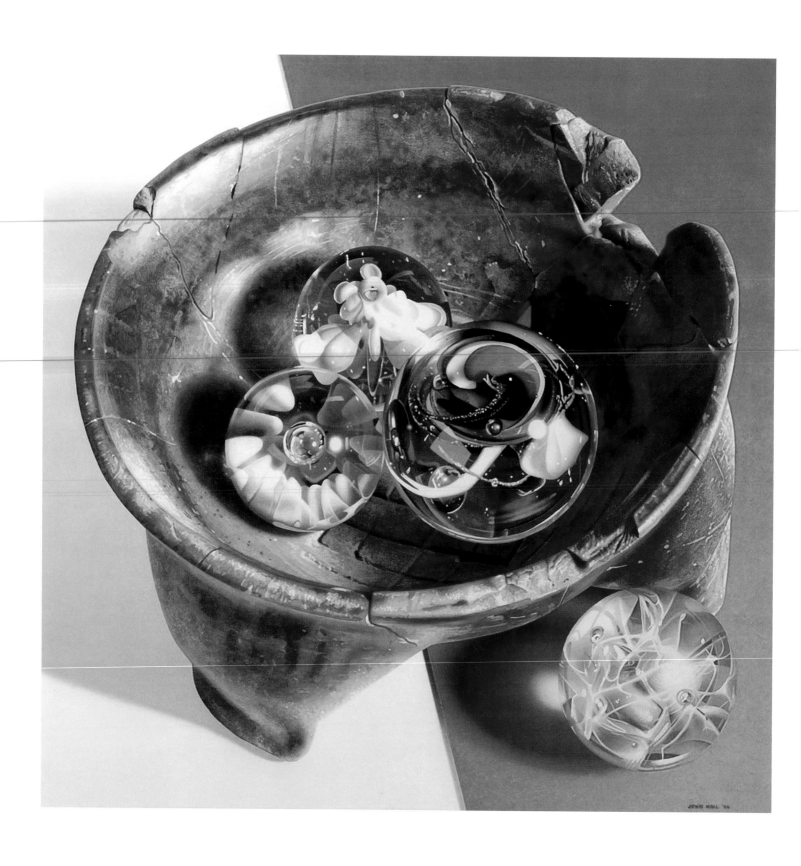

Oasis, 2006,
acrylic on canvas,
76 x 76 cm.

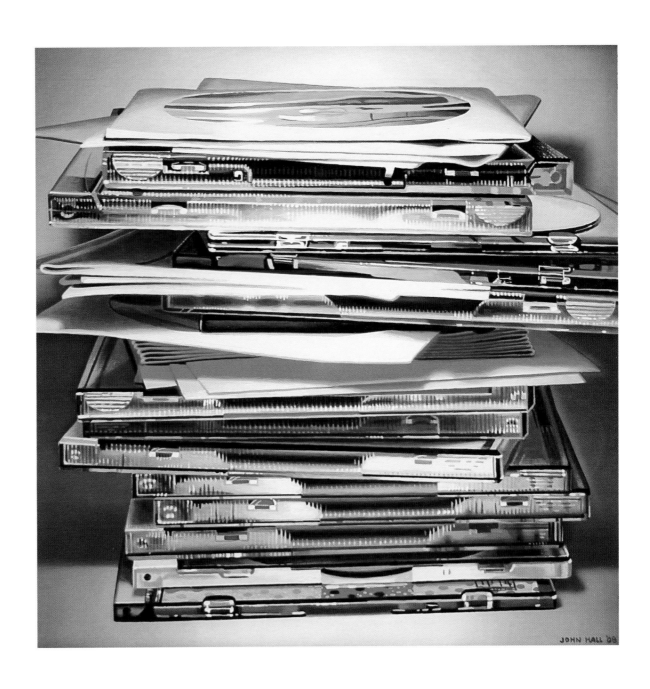

Quodlibet XLVII, 2008,
acrylic on canvas,
30 x 30 cm.

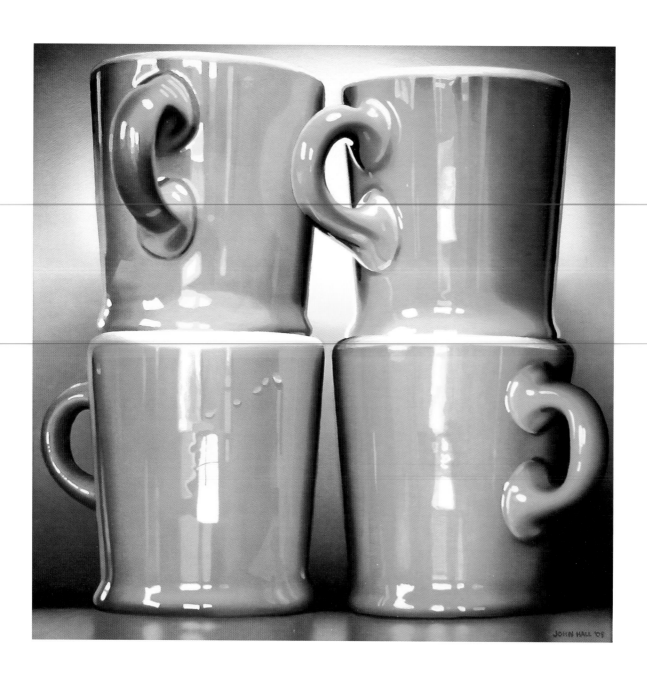

Quodlibet XLVIII, 2008,
acrylic on canvas,
30 x 30 cm.

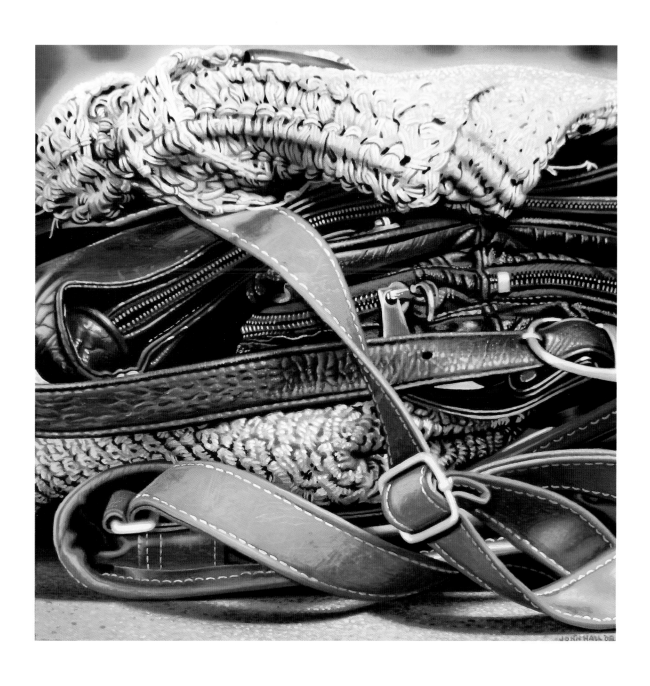

Quodlibet L, 2008,
acrylic on canvas,
30 x 30 cm.

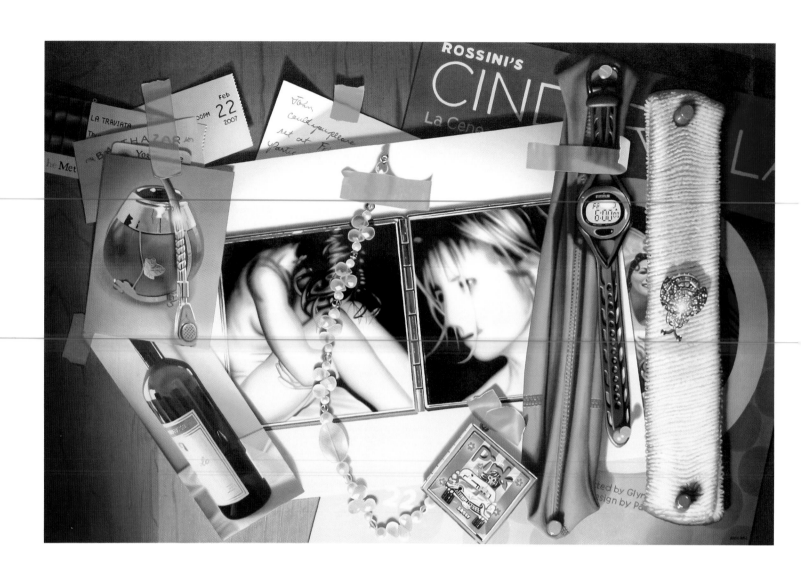

Passage, 2008,
acrylic on canvas,
61 x 91 cm.

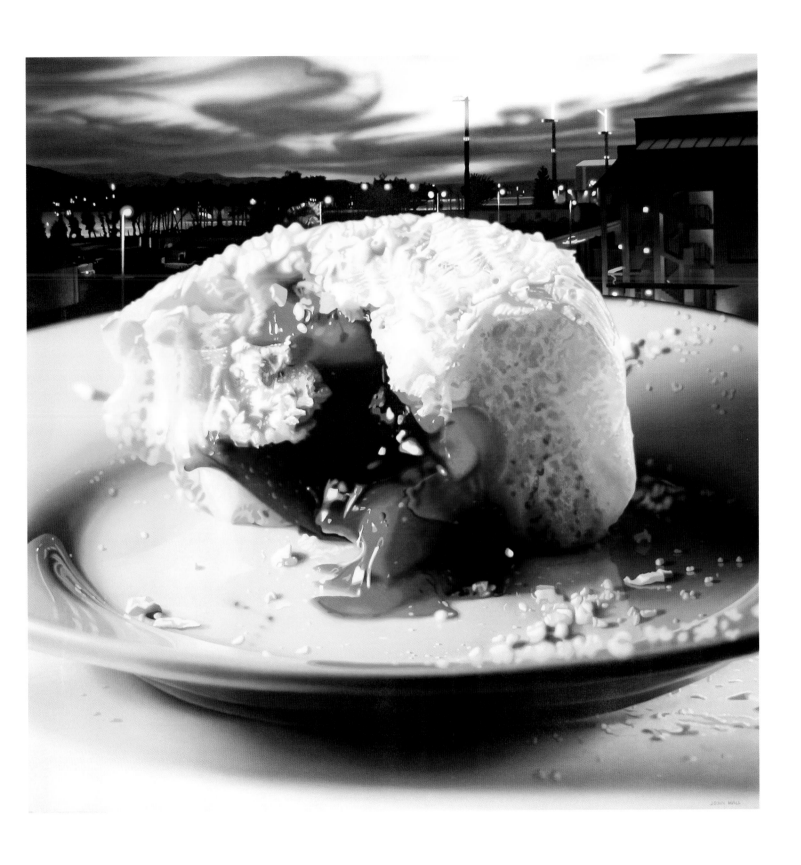

Jump, 2009,
acrylic on canvas,
76 x 76 cm.

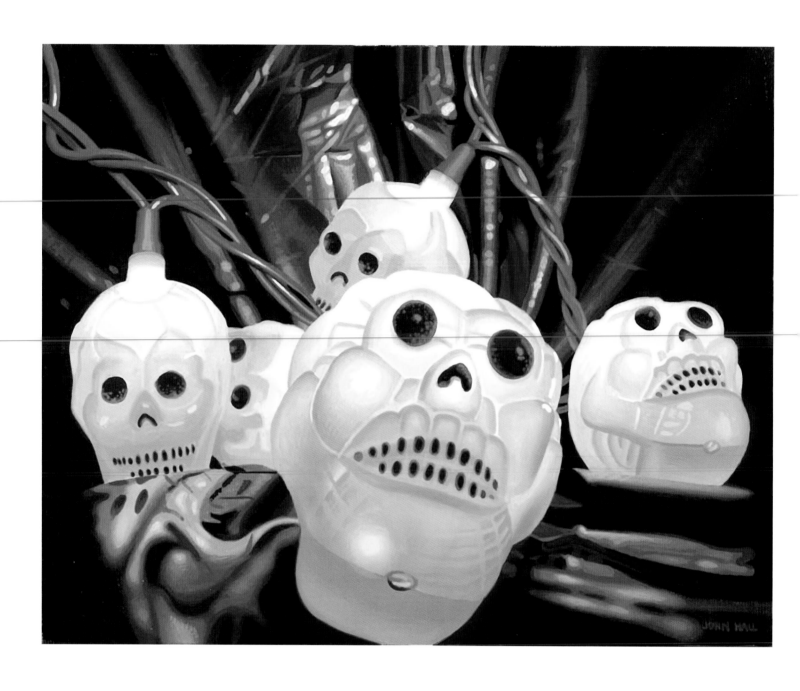

Avalanche 1, 2009,
acrylic on canvas,
20 x 25 cm.

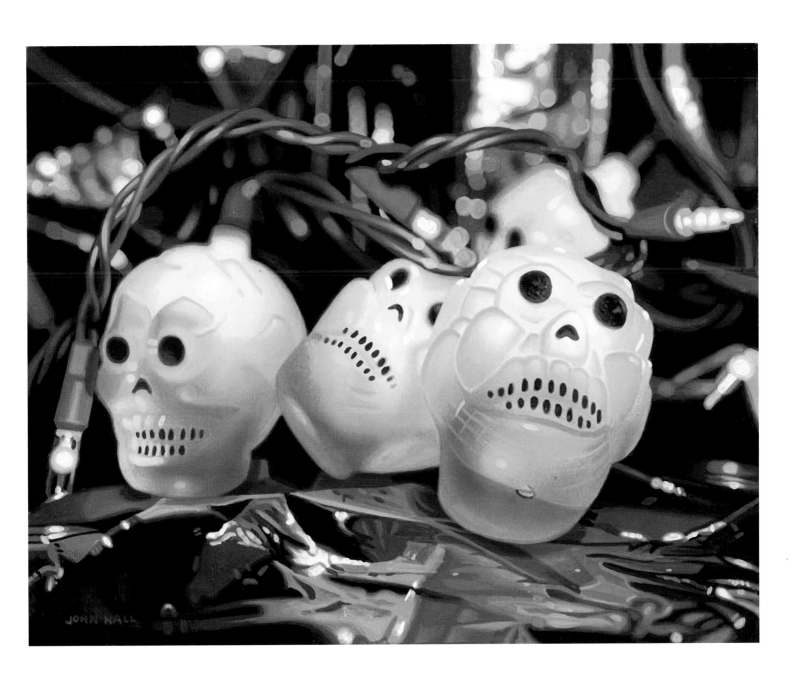

Avalanche 2, 2009,
acrylic on canvas,
20 x 25 cm.

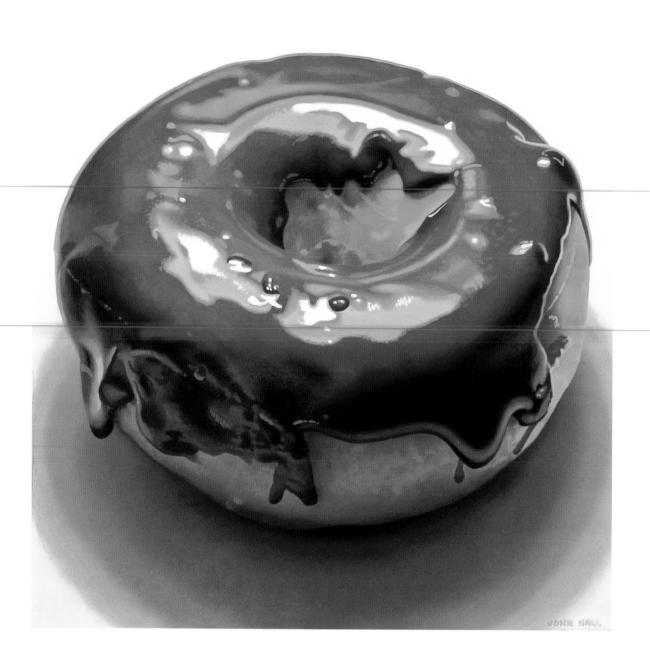

Orbit, 2009,
acrylic on canvas,
30 x 30 cm.

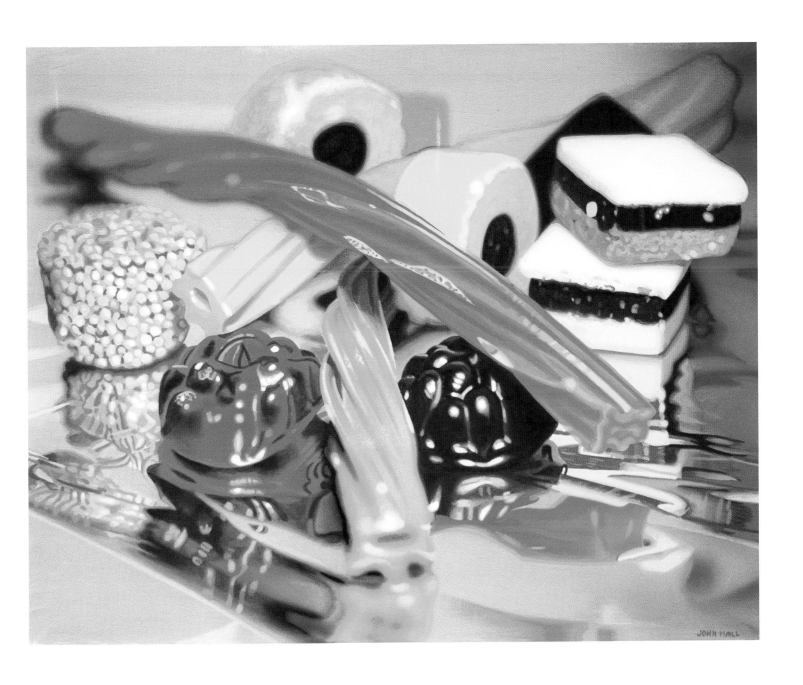

Snap!, 2009,
acrylic on canvas,
28 x 35 cm.

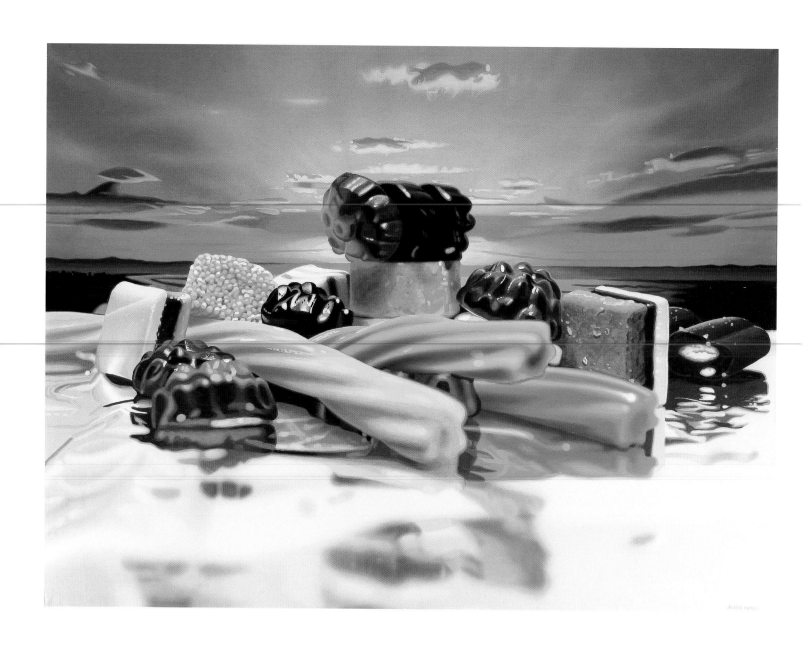

Zoom!, 2010,
acrylic on canvas,
46 x 61 cm.

The artist worked on a relatively small series of works called *Candela* between 2012 and 2014. The *Candela* works are all horizontal and in a variety of dimensions. Each of the twelve paintings in the series features a single stone sitting on a sheet of foil. The overall image has been manipulated with Photoshop so that it glows as though it is radioactive, with unearthly colours and highlights. *Candela: Saguaro/Tango* actually has a depiction of a lens flare painted into the work, a post-modern nod to his working method that has nothing to do with the human eye and all to do with Hall's now complex relationship between photography and his painting. The word candela is a scientific term in English meaning the measurement of intensity of light. It is also a Latin word that means candle. So once again Hall is maintaining that his paintings are all about light, nothing more, nothing less. But archetypally (and in dream interpretation, for example) a single stone can mean the self. Reverting to the compositional vocabulary of the *Quodlibet* stone paintings, Hall's last four *Candela* paintings contain a grouping of stones again.

Finally, Hall began his current ongoing series of works, entitled *Flash*, in 2014, and at the time of writing it comprises eight paintings, each of which depicts fruits or vegetables, often bagged up as though just brought home from the supermarket. In other works, such as *Flash: Drift* or *Flash: Clip*, the fruits and vegetables are out in the open, not bagged, and sit against fairly dark backgrounds, reminiscent of Dutch seventeenth-century still lifes or even the still life paintings of Edouard Manet, with their delicious grey backgrounds that act as effective foils against the colours of his fruits or flowers.

Since his coming to live in Kelowna in 1999, Hall's post-Calgary, post-Mexico work has a mellower feeling than his earlier Calgary and Mexican paintings. Although Kelowna is only a day's drive from Calgary, it is a world apart, and some would say the Okanagan Valley, where Kelowna is situated, is a world unto itself, a sort of arid Shangri La. Thrust into relative artistic isolation, Hall has responded by digging even more deeply into his studio practice. While some artists might have been tempted to wander out into the natural beauty of the Okanagan, Hall has no interest in painting landscape, and I have wondered at times if he has even looked out of his studio window! But the funky wackiness of, for example, his *Still Life Portraits*, is no longer at play in his paintings. His subjects seem a bit disembodied or floating, unmoored from any real context. Could this be termed the Kelowna effect?

Hall has not severed ties with Calgary, and he was included in a four-artist show including work by his wife, son and daughter, by the Art Gallery of Calgary in 2011. Over the years in Calgary, Hall showed with the former Canadian Art Galleries, the Newzones Gallery, the Wallace Gallery, and the Weiss Gallery. He signed with the multi-city Canadian dealer Loch Gallery in 2010.

A meaningful context for Hall's work is something to think about—and a real sense of where his work "fits" has shifted through the decades. Taking Derek Michael Besant's view, perhaps the realism in Hall's work is not the major aspect to be considered, and in fact might even be something of a stumbling block for viewers. Yet Hall himself still admires realist painting and keeps up to date with what various realist artists around the world are doing.

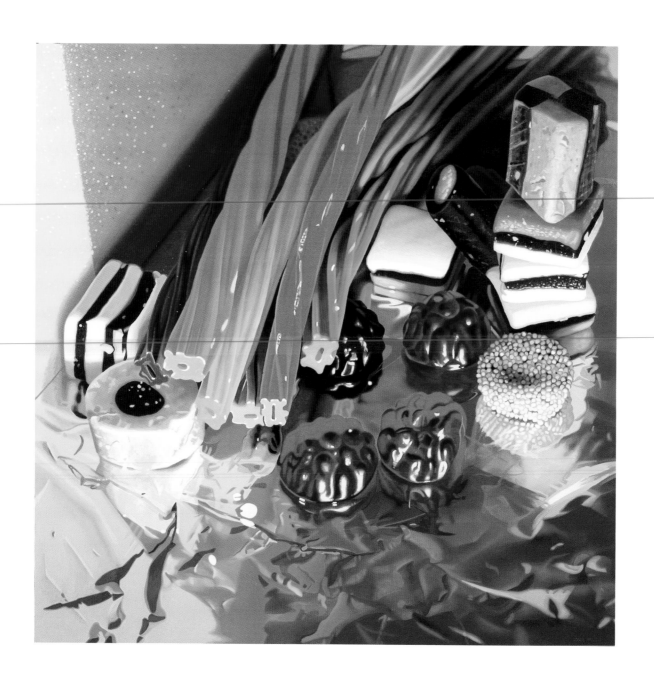

Krunch, 2010,
acrylic on canvas,
61 x 61 cm.

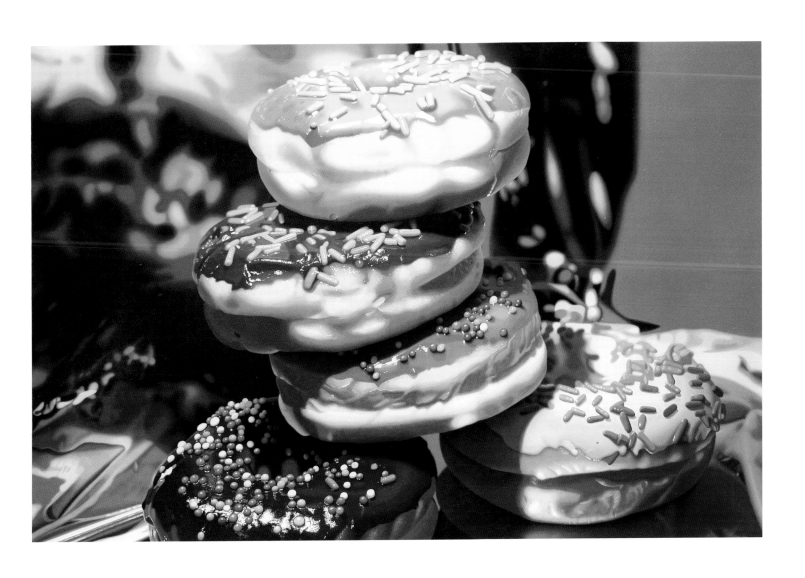

Ka-Pow, 2010,
acrylic on canvas,
152 x 229 cm

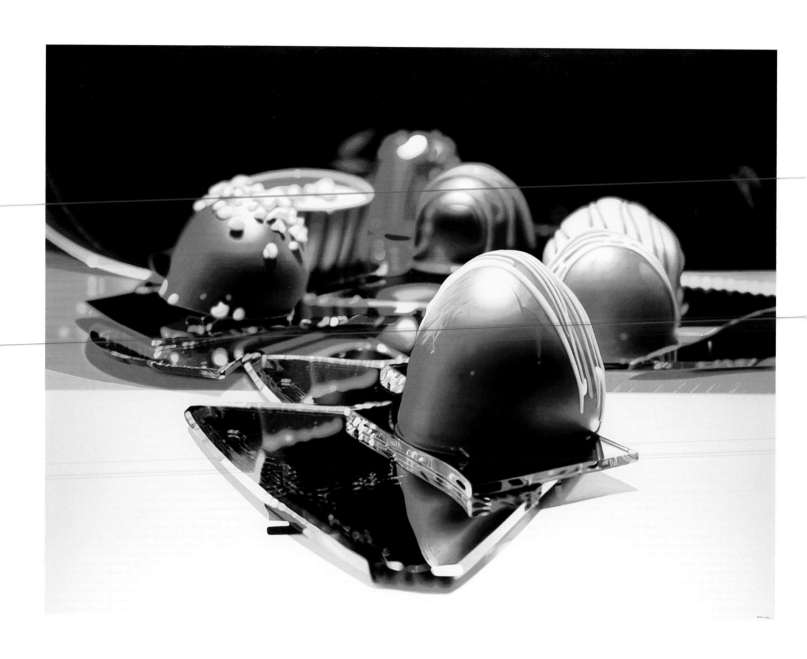

Rattle, 2011,
acrylic on canvas,
152 x 203 cm.

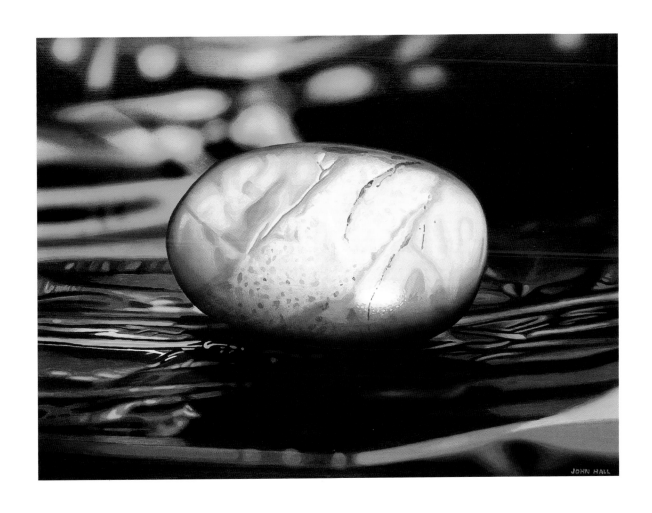

Candela: Ochre/Jade, 2012,
acrylic on canvas,
30 x 41 cm.

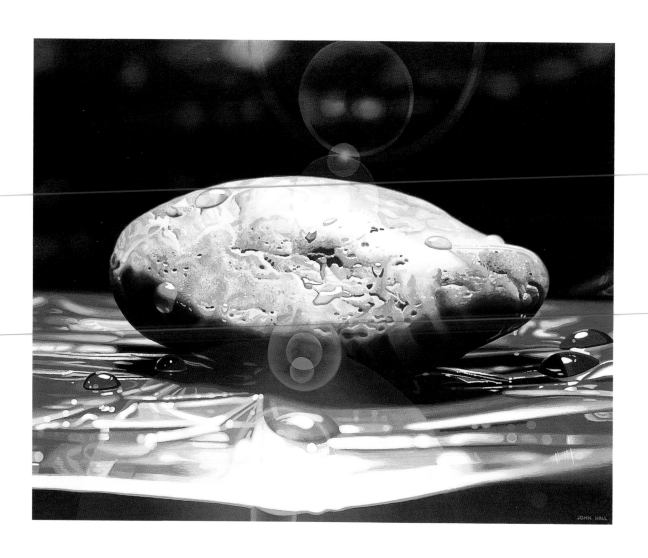

Candela: Saguaro/Tango, 2012,
acrylic on canvas,
41 x 51 cm.

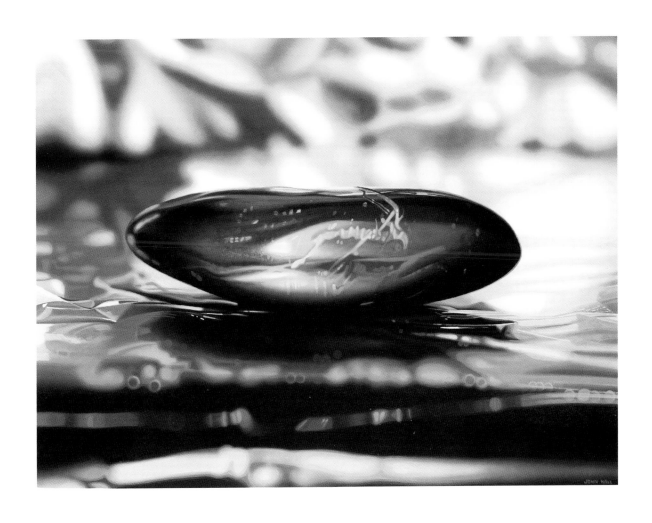

Candela: Cape Verde/Adobe Dust, 2012,
acrylic on canvas,
46 x 61 cm.

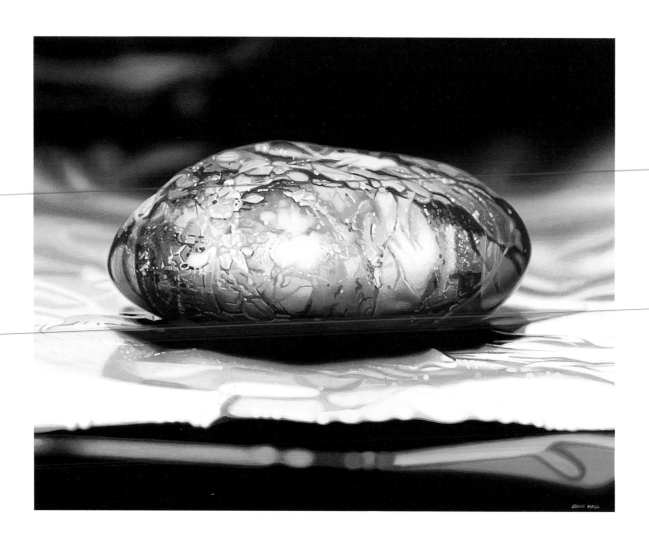

Candela: Bolero Red/Calypso Teal, 2012,
acrylic on canvas,
40 x 51 cm.

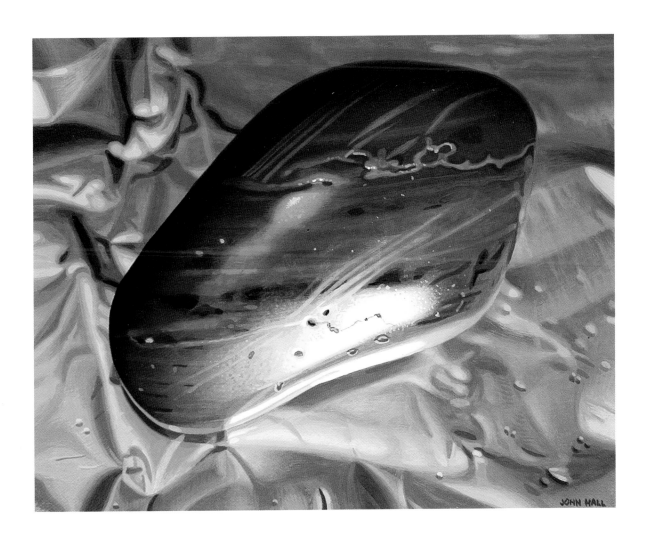

Candela: Turquoise/Magenta, 2012,
acrylic on canvas,
20 x 25 cm.

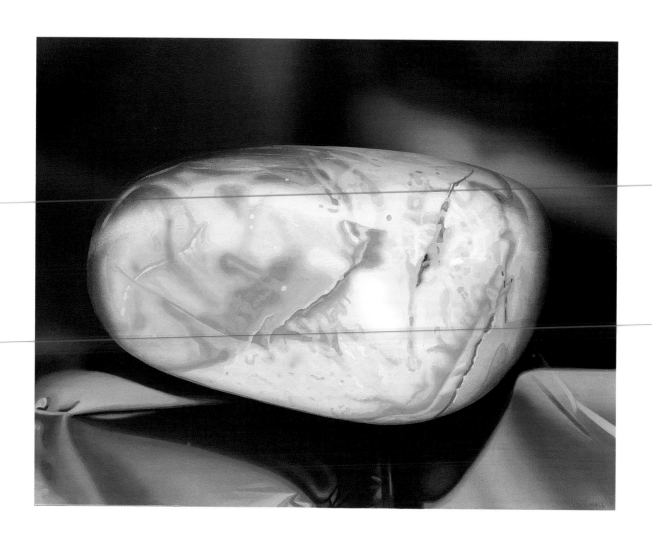

Candela: Redstone/Wizard, 2012,
acrylic on canvas,
36 x 46 cm.

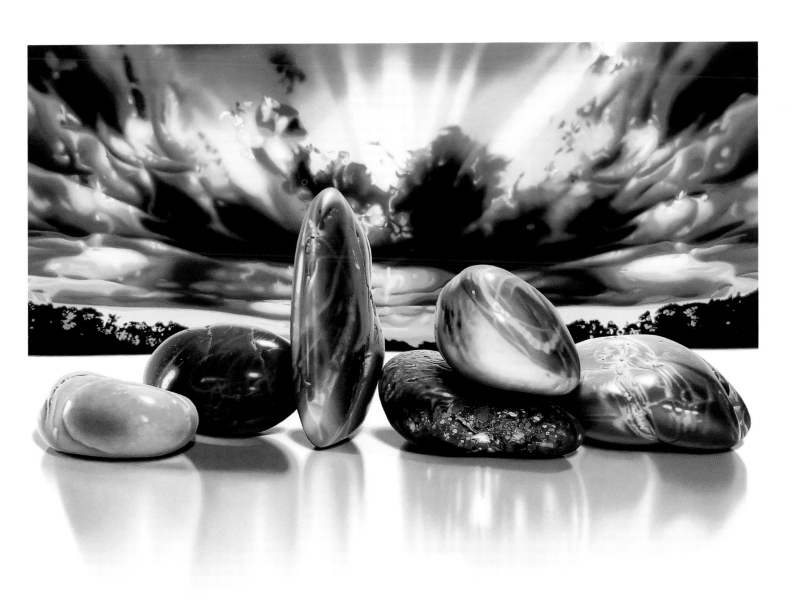

Candela: Fury, 2013,
acrylic on canvas,
114 x 142 cm.

He has mentioned that he admires realist painters who create a feeling of calm in their work and he cites the paintings of the late Canadian artist Jack Chambers, and the Madrid-based painter Antonio Lopez Garcia as being particularly inspirational. When he first began working in a naturalistic manner in the 1960s, Hall's work was cutting edge, especially in terms of its huge scale and grungy subject matter. By sticking with realism all these many years, however, he has created a hard row to hoe for himself, as so many people now apparently consider realist art to be old-fashioned and out of touch with current art practice. Two years ago Hall discussed this situation in detail in a published conversation with his former student, Alberta realist painter Keith Harder in a catalogue accompanying a solo exhibition of Harder's work.[8]

And what of Hall's insistence that his subjects are not important? There is a notion drawn from literary criticism known as the intentional fallacy, whereby one cannot take the artist's stated, conscious intention at face value when analyzing a given work.[9] A classic example of intentional fallacy in painting is a work from 1891 by Georges Seurat called *La Cirque*. Although the artist's stated intention was to produce a happy painting, it is, in fact, very sad in mood, and is a pretty macabre work. So, Hall may just not be consciously aware of the importance of his subjects. Or, looking at it another way, perhaps his so-called subjects—the souvenirs, dishes and candies—are not his actual subjects at all, but his art has a deeper, hidden meaning. What would this meaning be?—Surely nothing as specific as iconographically related to his painted objects, I don't think, but maybe something general, and quite replete with emotion. His Ralph Goings-diner-deadpan could be just a front, and sufficient to satisfy many of his viewers. But neither Derek Michael Besant nor Nancy Tousley were taken in, and it was their texts that inspired me to start thinking about this topic myself. Tousley pointed out, for example, that Hall likes to depict objects that are ambiguous, and I wonder if it is not the layers of meaning in an object that attract him at some level.[10] Ultimately, we know so little of ourselves, and of others as well. It seems we only discover who we are by going about living our lives. What matters is that we have lived, and that while alive we are connected to something, whether actually the reflection of light from the side of an object we feel compelled to reproduce in paint, or something else altogether.

ENDNOTES

1 Denver-based artist Daniel Sprick considers himself an heir to John Singer Sargent. This quotation of his appears in an essay on his website by Jane Fudge, taken from a Denver Art Museum brochure from 1999.

2 Interview with John Hall by Robert Enright, "Odd Man Out: an interview with John Hall", *Border Crossings*, Vol 8, No 3, summer, 1989, p 19.

3 Tousley, Nancy, "John Hall's Still-Life Portraits", *Imitations of Life: John Hall's Still-Life Portraits*, Kingston, Ontario: Agnes Etherington Art Centre, Queen's University, 1989, pp 24–25.

4 Tousley, *Imitations of Life*, 1989, p 10.

5 This show also travelled to the Museo de Arts Contemporaneo in Aquascalientes, Mexico, and in abbreviated form to the Glenbow in Calgary in 1994, and the Art Gallery of the South Okanagan, in Penticton, British Columbia, in 1996.

6 See Besant, Derek Michael, "John Hall / Traza de Evidencia," *John Hall: Traza de Evidencia*, Mexico City: Museo de Arte Moderno, 1992.

7 Besant, *John Hall*, 1992, p 10.

8 See this text in *Keith Harder: Observation and Invention*, Penticton Art Gallery, 2013.

9 See Wimsatt, WK and Monroe Beardsley, "The Intentional Fallacy", *The Verbal Icon*, Lexington: University of Kentucky, 1954.

10 Tousley, *Imitations of Life*, 1989, p 25.

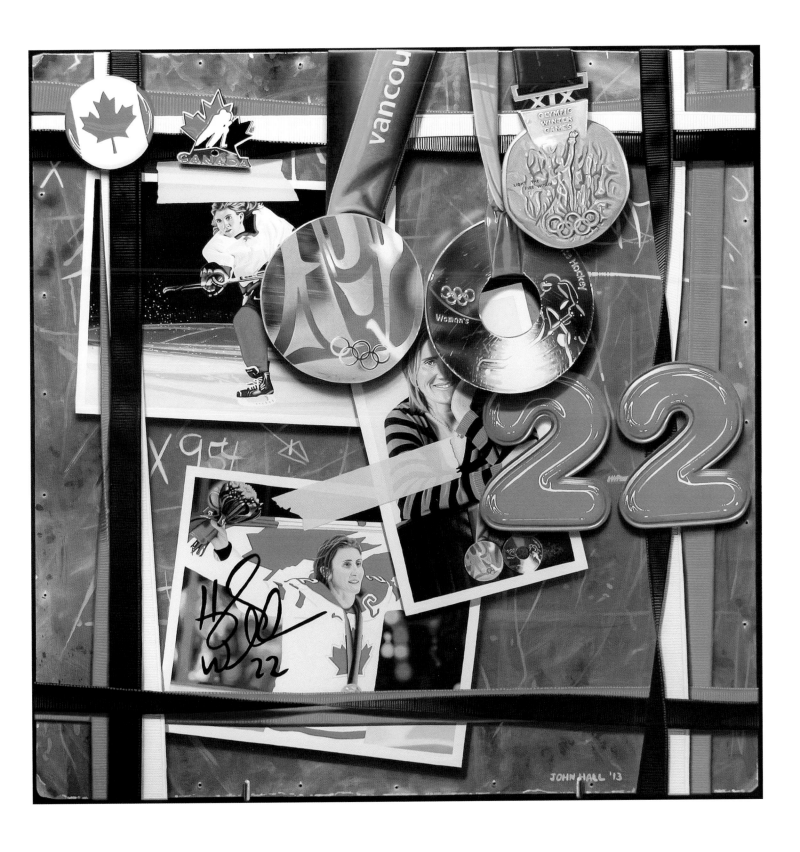

22 Hayley Wickenheiser, 2013,
acrylic on canvas,
91 x 91 cm.

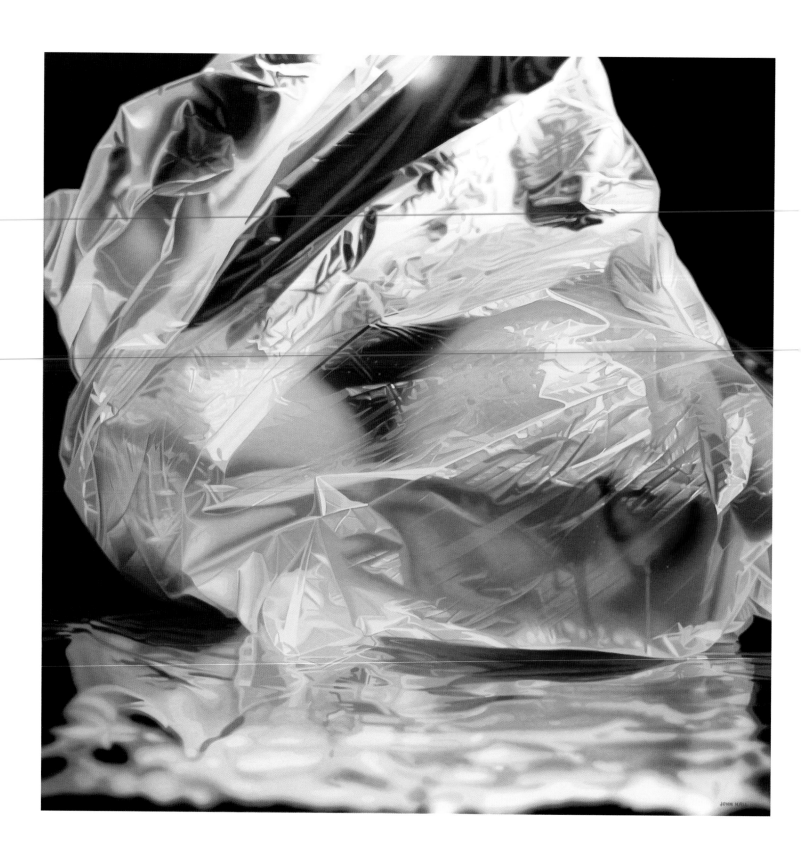

Flash: Splash, 2014,
acrylic on canvas,
91 x 91 cm.

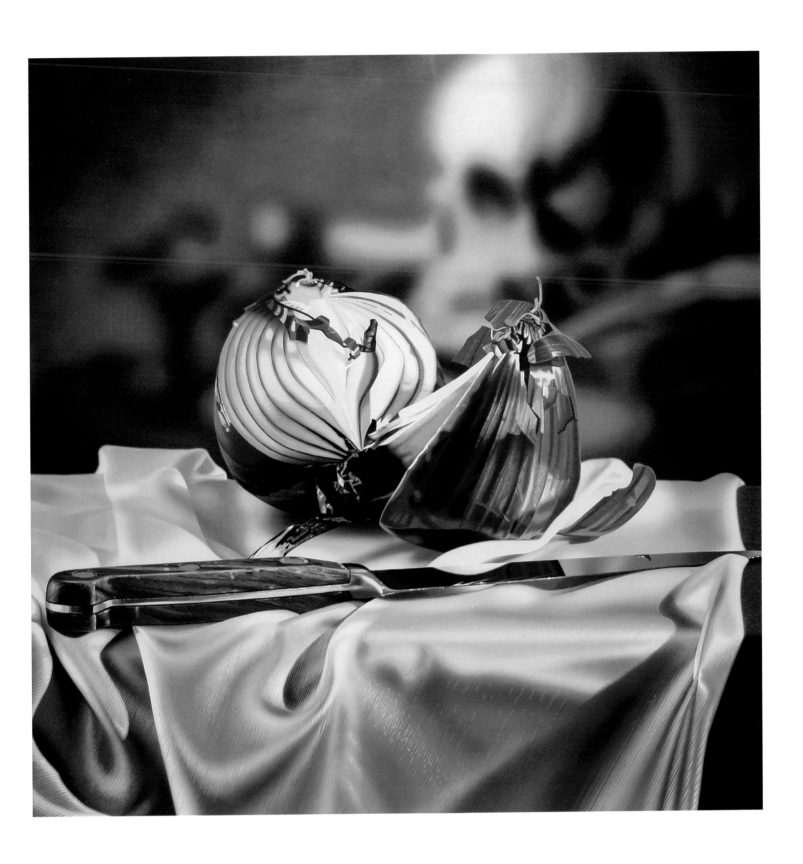

Flash: Clip, 2015,
acrylic on canvas,
91 x 91 cm.

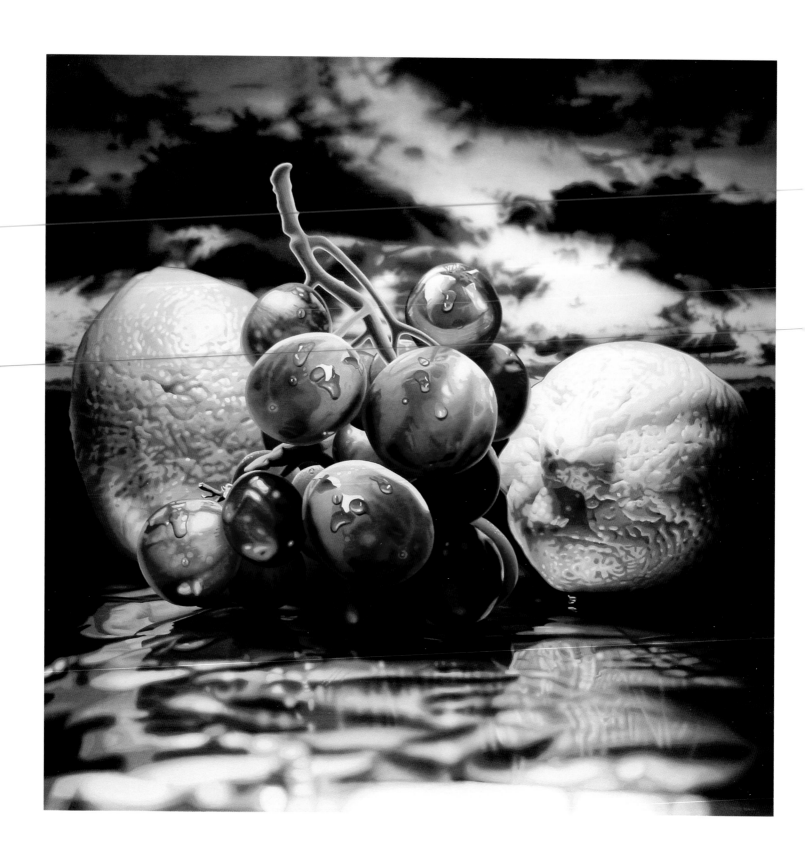

Flash: Drift, 2015,
acrylic on canvas,
91 x 91 cm.

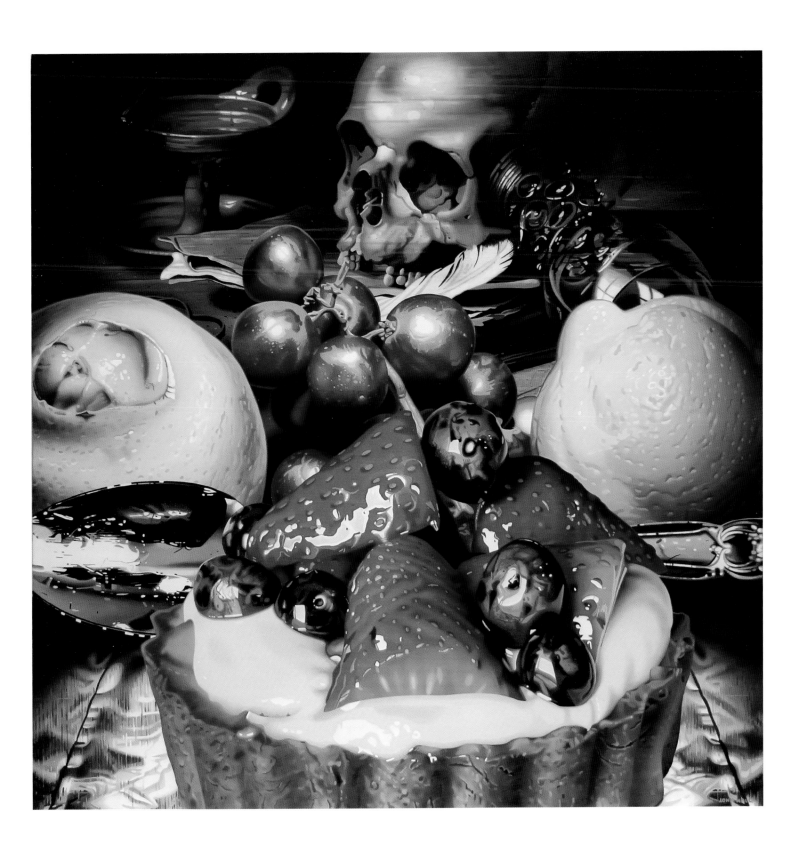

Flash: Juke, 2015,
acrylic on canvas,
91 x 91 cm.

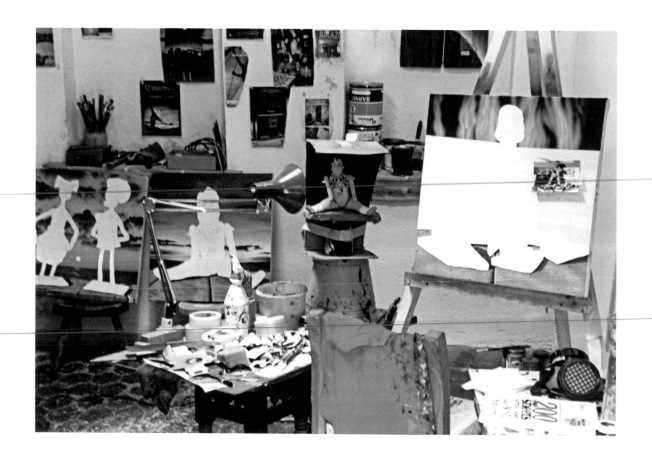

John Hall at work in his
studio, San Miguel de
Allende, c 1988.

ORDER AND RITUAL:
JOHN HALL IN AND OUT OF MEXICO

Alexandra Haeseker

Artists' works trail out behind them like a wake from a boat. Often while artists are in the midst of working, their destination remains invisible. Only years later, with perspective, does clarity emerge for both the person who made the work, and the artists' audience. This text is my look into the persistence of Mexico on the studio practice and inspiration of Canadian artist John Hall. The story of this is bookended, beginning with four friends—two artist couples—John and Joice Hall and my husband Derek Besant and me, and ending with John Hall leaving Mexico to live and work in Kelowna, British Columbia.

For a decade in the 1990s, we shared the experience of living, working, and exploring deep into the heart of Mexico for half of each year, and we enjoyed the frequency of social visits between our respective studio residences. Evenings together would always begin by lingering where our ongoing work was laid out; we could witness each other's progress from week to week, and see bodies of work emerge that would later become exhibitions that were shown in museums in Mexico and Canada.

I was fortunate to be witness to the powerful subjective influence of Mexico on John Hall's paintings from the very beginning of this process. From 1966 to 1968 I studied in the advanced classes at the Alberta College of Art in Calgary, shortly after John had graduated from there. He won the prestigious Sauza Tequila Award, allowing him to work for a year at the Instituto Allende in San Miguel de Allende, in the state of Guanajuato, in central Mexico. The still-life paintings he did there using local Mexican materials were shown at the gallery of the Alberta College of Art upon his return.

Mexico—the word conjures up verdant visions of tropical delight—trees abundant with fruit, blue seas and warm beaches, mountain ranges and volcanoes—sounds of flamenco, church bells, revolutions—burros, men in white cotton pants, and women behind fans who dance to guitar music, birds of paradise, nights of fireworks…. Little did a then-twenty-two-year-old graduate from the Alberta College of Art (ACA) know, as he arrived at San Miguel de Allende in 1965 with his young wife and new baby daughter, in their dust-covered car, that this place, its setting virtually unchanged since the sixteenth century, 1,920 metres above sea level, between the arms of the Sierra Madres, on the southern tip of the Chihuahua Desert, would allow him to create some of the most idiosyncratic paintings in his artistic career.

The Instituto Allende in San Miguel was a studio-based art school. Two earlier important ACA graduates who studied there were artists Ron Spickett and Roy Kiyooka. John followed in their footsteps, relishing the fact that the Bellas Artes in San Miguel de Allende (within walking distance) actually housed two murals by the Mexican artist David Alfaro Siqueiros. Additionally a major mural by Diego Rivera was in the opera house in Guanajuato (half an hour away), and the museums and galleries of Mexico City were a three-and-a-half-hour bus ride away. There he could visit the famous studio/houses of Diego Rivera and Frida Kahlo, and saw first-hand their surroundings, collections of folk art, *retablos*, and pre-Columbian figurines. The ghosts of these past artists urged Hall on in his quest as a young painter from *el norte*.

San Miguel de Allende—cut-stone churches housing effigies of saints with bleeding eyes, Virgins in trailing robes sewn with cast metal *milagros*, plus on Good Fridays, a crucifixion enactment ritual an hour away at Atotonilco, followed by the famous annual Easter Sunday silent funeral procession in the cobble-stoned centre of San Miguel. This last ritual is timed for sunset, when torches are lit, and statue idols of the Passion are worshipped as chosen citizens carry their weight solemnly through the streets. Catholicism is on display at its most gaudy and spectacular.

On non-holy days, the market streets in San Miguel have vendors calling out like town criers, and women stack limes, mangos, and avocados. There are tables bearing arrays of items constructed in metal, wood, and plastic. Bigger hand tools and household wares are laid out on ground tarps in splendid disarray. There are flower sellers and a toothless cinnamon stick vendor—waving away the exotic Monarch butterflies that migrate thousands of miles over the continent. Along with Tequila Maguey plants, there are purple-blooming Jacaranda trees, thorny Huisaches, tangled Mesquite trees, plus Garambullo, Walking Man, Barrel and Nopal cacti, all of which define the timeless desert landscape. For a painter, Mexico could be a true bombardment of the senses. The place gave John a new freedom to bring to his work. All around him was different subject matter, certainly, but more than that, he could now and did enter into a new complex and subtle narrative in his still-life paintings, one that had both invited and uninvited influence he simply could not ignore.

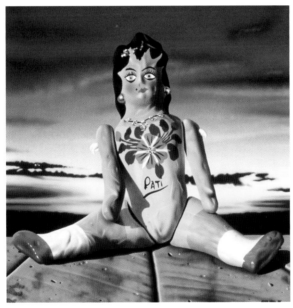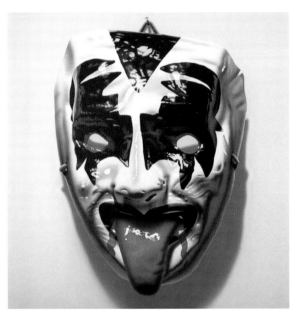

Tlaxcala, 1988,
acrylic on canvas,
61 x 61 cm.

Guerrero, 1988,
acrylic on canvas,
61 x 61 cm.

Sinaloa, 1988,
acrylic on canvas,
61 x 61 cm.

Campeche, 1988,
reworked in 2002,
acrylic on canvas,
61 x 61 cm.

Zacatecas, 1988,
acrylic on canvas,
61 x 61 cm.

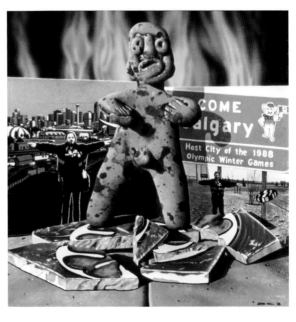

In 1987, twenty-two years after John's Mexican sojourn of 1965–1966, Joice and John rented a house for four months in San Miguel to work, and they invited Derek and me to come to visit. They met us at the airport in Mexico City, and we took a local bus together to San Miguel. We arrived in the dead of night, with a luridly lit tuba band and singer performing in the town square. We walked through the cobble-stoned streets, past the open doors of a coffin shop with poignant small white boxes stacked like pale reminders, with a flickering glow of street lamps keeping time with the rain. During the days that followed, John and Joice encouraged us to explore the town on our own, while they continued to follow their well-defined studio discipline: working on their paintings during the morning hours after breakfast, then through the afternoons after lunch, until dinner and sunset marked the end of the work day. Then it was time for us to reconnect. Their timetable was familiar to us from our own mutual experiences of producing bodies of work for scheduled exhibitions at our dealers' art galleries in Canada.

For John, the quest was ongoing for local hand-made tourist items, kitsch ceramics, sewn fabric dolls, perforated metal lanterns, and wooden crucifixes, which he would use for painting. He would set up his finds against simple grounds as individual representations of each of the thirty-two states of Mexico. The names of these areas are evocatively foreign and mysterious to Canadians, the objects humble but their displays shrine-like. With his obsessive daily painting schedule, there was something stirring within John that unleashed an underlying urgency in his series of small-object paintings. The work was an exercise in description—of how to render the crude surfaces of glazed details on a fired clay rooster, or capture the slap-dash paint application of features on a coconut husk mask. John set his aim as a realist to translate those underdog trinkets into skillfully rendered images of wonder, illuminated by sunlight against ghastly coloured grounds. His method seduces a viewer due to the rich treatment the objects are given, but is subtly submerged under what John called "the skin of the painting". His paint handling was cool and understated, deceptively neutral in his de-constructed formula of planes of colour, with shadows and highlights to set these apart within his shallow pictorial space. John could paint with great economy, and he could paint anything he set up in front of his easel! His thirty-two "state" paintings also followed the seventeenth-century Dutch painting formats of *pronkstillevens*, in which the space was usually dark and enveloping, with a flat table surface on which an arrangement of lushly described objects are displayed. These relate both in their context as well as sub-textual meanings to one another.

During that same visit in 1987, on a rooftop patio in the heart of Mexico, on a night live with salsa music playing in the street below, under a shooting-star night sky John, Joice, Derek, and I began a lively discussion about Peter Greenaway's films, Simon Schama's books, our upcoming exhibitions in Toronto, and what each of us was working on in our San Miguel studios. Derek proposed the question to John: "When are you going to do an exhibition of this work in Mexico?" John's response was pessimistic: "Who is going to arrange that?" To which Derek recklessly replied: "Well… I am!" And with the launch of that trajectory, Derek remained good to his word. During the next five

years John concentrated on producing a body of work for this show, at the same time as meetings were set up in Mexico City, the Canadian Embassy was brought on board, corporate business partners were secured, the catalogue was designed, international cultural grants were strategized, and the exhibition Traza de Evidencia was scheduled as a feature show at the prestigious Museo de Arte Moderno in Mexico City. It opened there in 1993, and then travelled to the Glenbow in Calgary afterwards. The work John had produced for this would prove to be a huge success, in his outlandish sacred and profane treatment of the subject matter, and a tour-de-force handling of both paint and scale.

Artist Alexandra Haeseker with John Hall in San Miguel de Allende, c 1988.

John Hall being interviewed in the gallery space at his exhibition Traza de Evidencia, at the Museo de Arte Contemporaneo, Aguascelientes, Mexico, 1993.

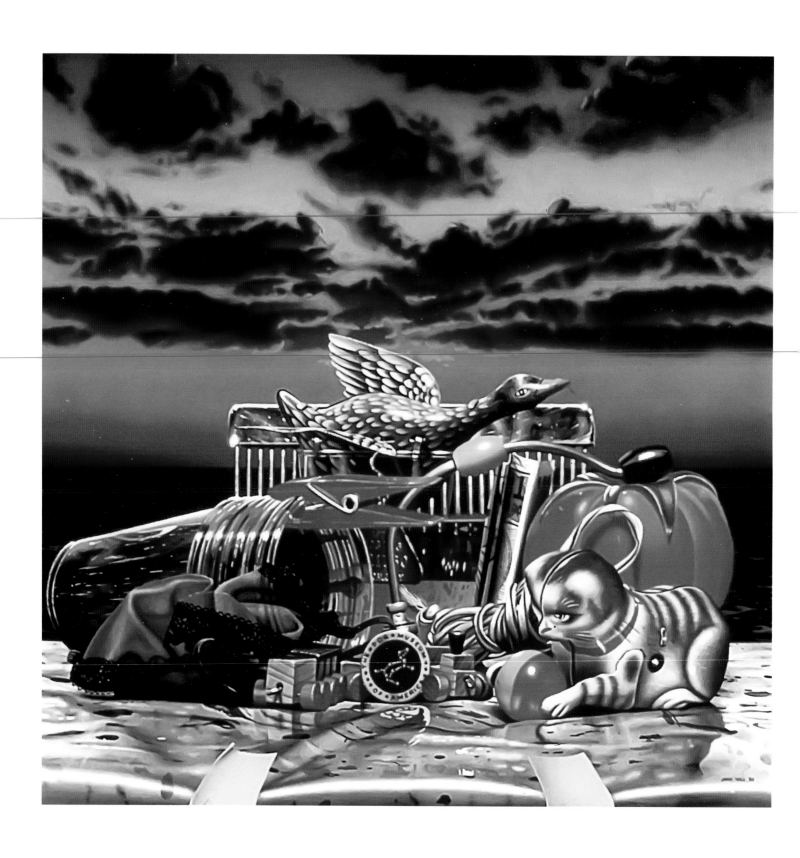

Medusa, 1989,
acrylic on canvas,
91 x 91 cm.

During the years following our significant 1987 time together in San Miguel, with its sky-is-the-limit rooftop revelations, Derek and I visited John and Joice Hall several subsequent times to further the plan and set all the parts in motion. By 1988 they had settled into their own new house and studios on the hill above town in order to seriously commit half of each year to living and working in Mexico.

During one of our visits, John gave Derek and myself ten pesos each and we were sent to the tuesday market in town to purchase objects of our own choice as subject matter for his *Disposicion del Mercado* series. When we returned with our stuff, John set up sites for it all in their sunlit garden—still-life set-ups to be photographed for potential paintings. As the eclectic conglomerations took shape, Joice casually placed fresh cuttings and debris from her garden trimmings into the theatrical small scenarios of random objects as *pièces de résistance*, completing the reference to seventeenth-century Dutch still-life paintings that depicted earthly wealth with underlying *memento mori*.

John developed a metaphoric resonance in his work, and seemed to be considering the underpinnings of still-life in new ways. Already he had been painting "portraits" of people he knew by inviting each to present him with an unassuming box of personal objects, from which he would construct an evocative image, without the physical likeness of his model. A still-life portrait of me, *Medusa*, from 1989, is an intriguing example, with its fading smoke-cloud sky, seen at just the moment after the sun has dropped below the horizon. There is an intricate intertwining of metal objects that includes my pin from the American Dog Museum, a little wooden train from my childhood, two tin wind-up toys, a squeaky dog toy tomato, plus my studio plastic cups for mixing paint. All are odd things that anyone would overlook as being personally significant. But John's orchestration of the event is conducted as if one is in a darkened theatre, with the curtains just parted, stage lights up and the feeling that a tragedy or passion play is about to begin.

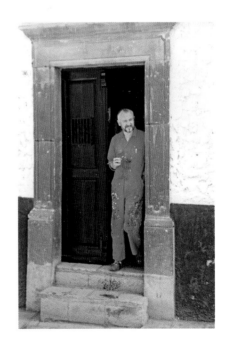

John Hall in the entrance of their rental house on Calle Tenerias, in San Miguel de Allende, c 1988.

Another deeper level of *deus ex machina* welcomed as a catalyst for creating imagery happened when John received a box of possessions from a stranger who had seen some of his work in an exhibition. A Dutch actress who revealed herself by only her first name, "Brigitte", was interested in a commission. John's 1990–1992 *Brigitte* paintings tread into darker territory, possibly because of the distance between the artist and sitter, connected only through short bits of correspondence. Paintings from Brigitte's personal paraphernalia include a black velvet glove, unidentified pills, a black leather purse, a red bra, and some plastic toy figures (including one of Wonder Woman). Also appearing is a strip of film negatives—which, assembled and reassembled time and again—became a set of twists and turns worthy of a detective novel. The enigma of Brigitte as portrayed by John continued for several years, but only as a long-distance dialogue about her belongings and his infatuation with her as a distant muse… until a tragic plane crash ended her life.

John Hall arranging materials to photograph to create his La Disposicion del Mercado paintings in San Miguel de Allende, Mexico, c 1992.

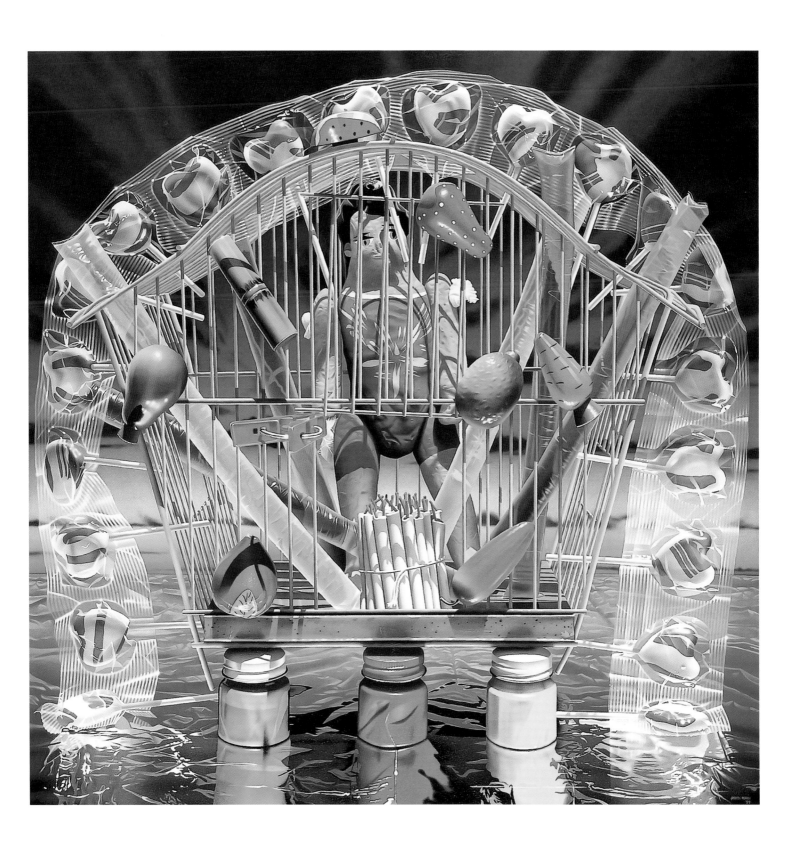

Cielo Vespertino, 1993,
acrylic on canvas,
152 x 152 cm.

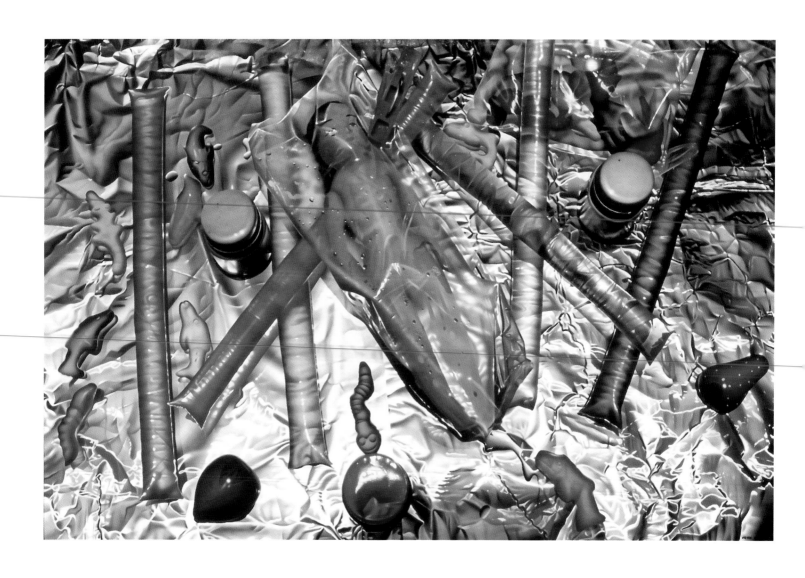

Alejandra's Ophelia, 1993,
acrylic on canvas,
84 x 124 cm.

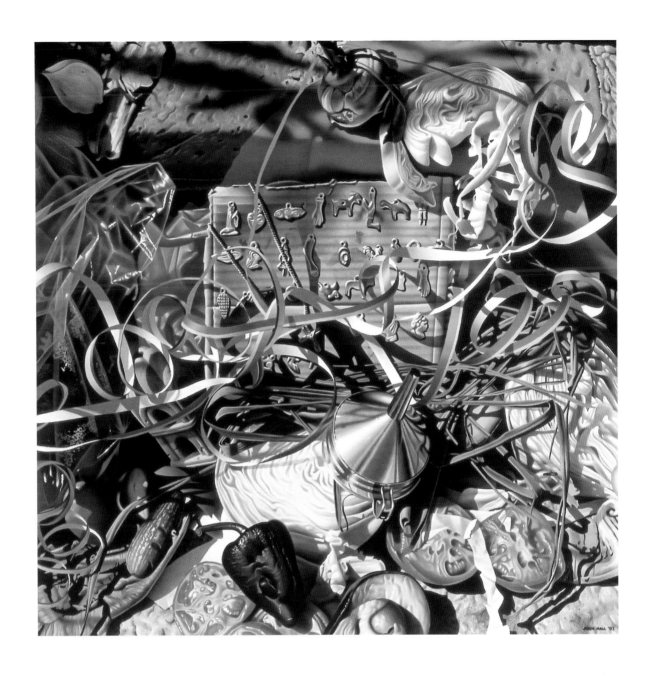

Milagros, 1993,
acrylic on canvas,
91 x 91 cm.

Within our collective interest in historical Dutch still-life painting, another two characters became involved in providing John with subject matter over a long distance: Marijke and Gerda de Wit, two performance artists from Amsterdam. John's painting took another leap forward, in which the accidental was welcomed warily. From this point on, John effectively began to deconstruct his compositions as gestures beyond the Baroque and into the grit and grime of abundance and beautiful destruction. Paper bags have toppled and their contents spilled out like eviscerated cargo oozing from a sinking tanker. The laws of gravity are not only upset, they create a cornucopia of clues as to the joint identity the de Wit sisters' objects ascribed to: Who is that in the framed photograph? Is that a real gun? Is that the artist's own portrait reflected in the glass or a reference to the viewer as voyeur? John's paintings seem to trip into the picture plane, and move outside of the safe confines of the frame. With these paintings he had crossed a line—beyond the presented opulence of the Dutch protocols—to one of the highest realms of what painting can elicit. It is at this point in his career that subject, object, narrative, and meaning collide into mastery.

Although John Hall set up his subject matter in the same way as the inspirational historical Dutch artists had done in order to portray their society's values, John's subjects were far from symbolizing mercantile heights of power. His sugar-candy skull confections, broken decorative tiles, a papier mâché lacquered rattle, one of his own coffee cups, and a hand-blown drinking glass, are not exactly treasured items symbolic of an embarrassment of riches. John chose an ironic stance in choosing to paint such everyday things and painting them larger than life, while articulating his painter's touch such that he did not leave signs of the painter's hand. The interplay between himself and the viewer reveals his technical virtuosity, which set him outside the context of realist counterparts of the day. As a displaced Canadian artist working in Mexico, John was not following any of the trends of art being exhibited in Toronto, Montreal, or Calgary. John Hall was simply painting as a writer might write, isolating himself with the hope of achieving a clearer vision as an observer of his surroundings.

Hall's next work begun in Mexico was a collaborative series worked on with myself that we titled *Pendulum/Pendula*. The initial idea for this came to us during our 1987 visit. John had pointed to a half-finished painting poised on his easel, and spontaneously invited me to paint something of my own choice somewhere in the composition. The short time we were in San Miguel that year did not allow me to try, but the notion of working together on a single canvas lingered. Over the next few years we set the idea in motion. In retrospect now, of course, the collaborative *Pendulum/Pendula* paintings that we created were a physical manifestation of the ongoing studio visits and work discussions we entered into so naturally when our respective Mexican studios were within walking distance of each other.

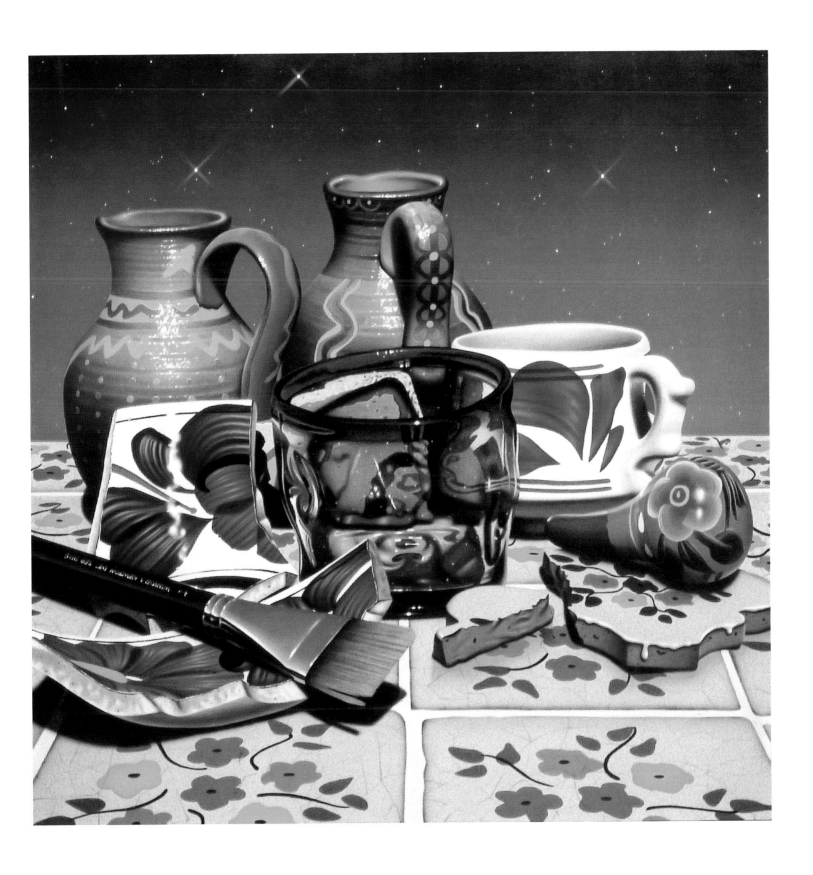

Allende, 1984,
acrylic on canvas,
102 x 102 cm.

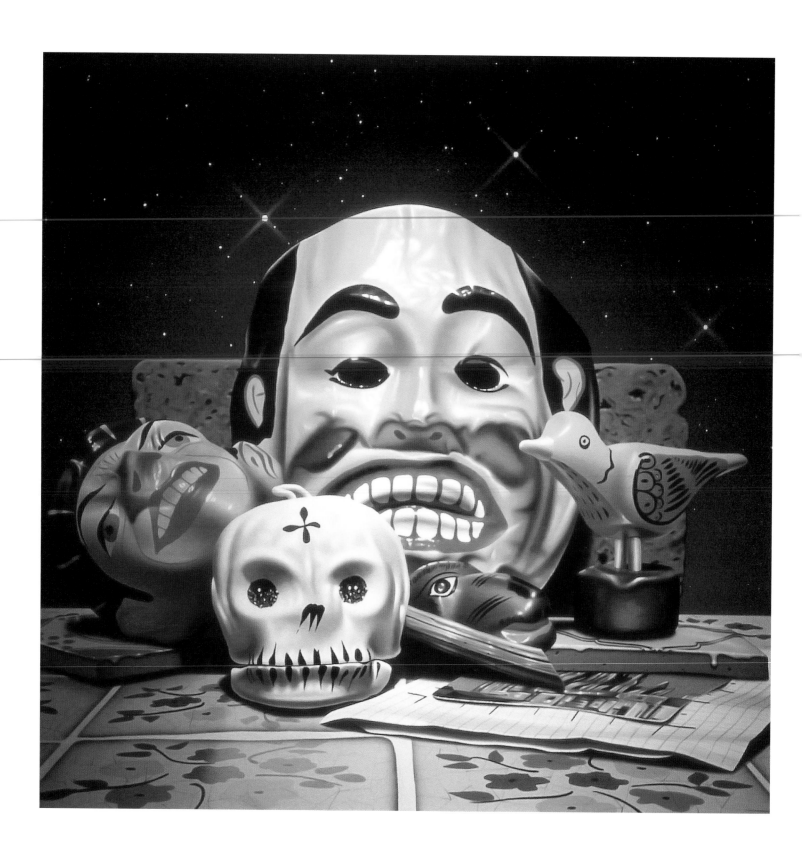

Hidalgo, 1984,
acrylic on canvas,
102 x 102 cm.

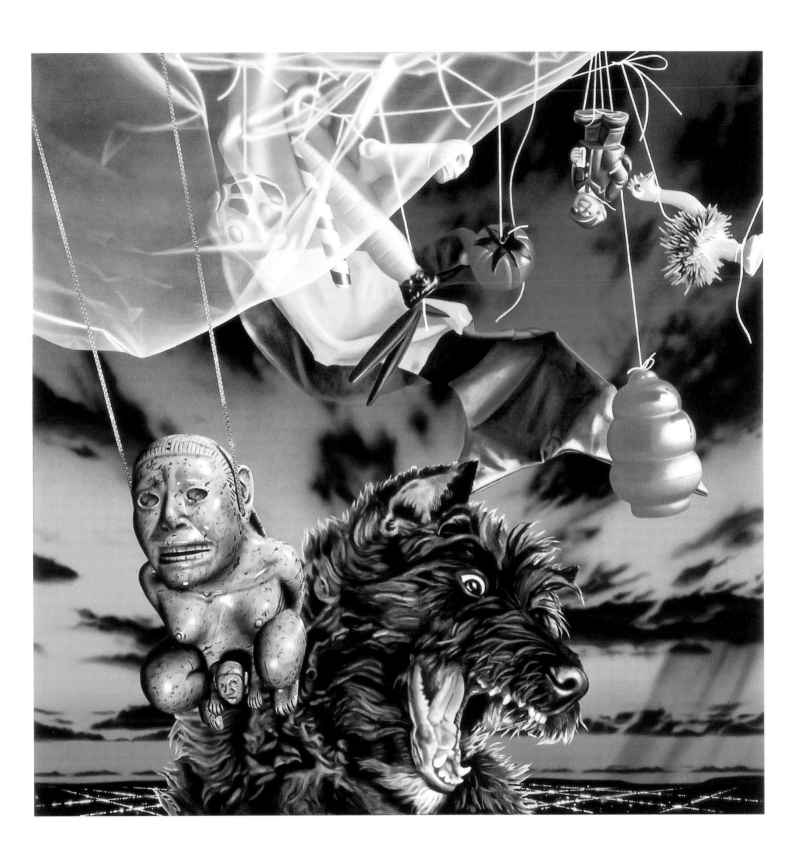

Pendulum I, 1992,
acrylic on canvas,
152 x 152 cm.
Painted in collaboration with
Alexandra Haeseker.

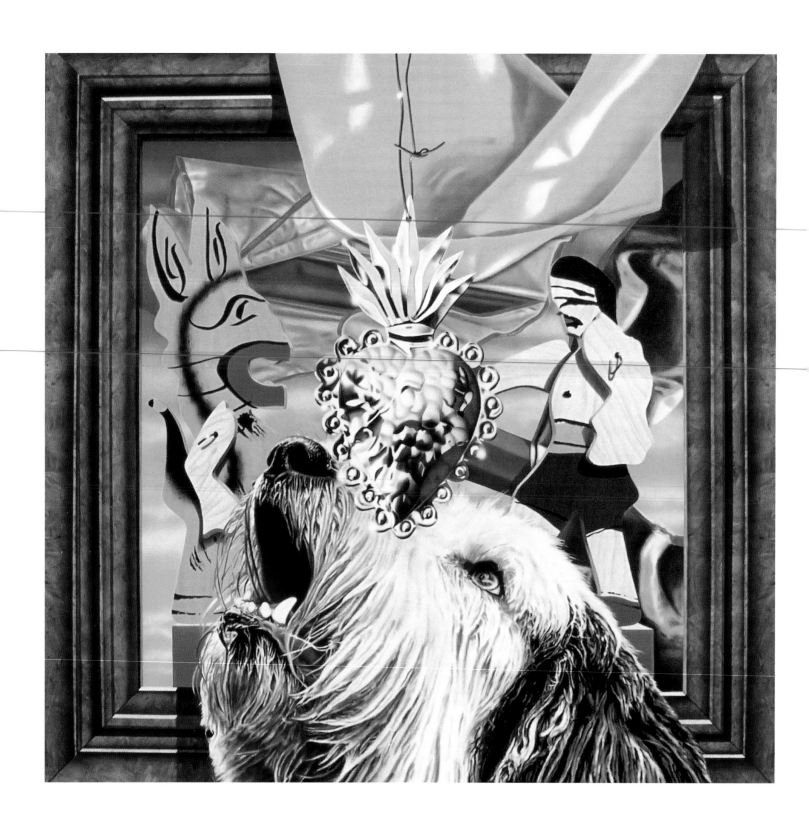

Pendulum II, 1993–97,
acrylic on canvas,
152 x 152 cm.
Painted in collaboration with
Alexandra Haeseker.

Pendulum I and *Pendulum II* used the simple strategy of each of us starting a canvas, and covering about fifty percent of the surface with our own imagery, then passing it to the other to finish. Needless to say, we had to pass the canvases back and forth a number of times, with massive revisions, before we achieved the desired effect we could both agree on. These initial *Pendulum/Pendula* paintings started as territorial encounters, directly on the canvas: John's subject matter, then mine; his Mexican artifacts, and my alert, desirous dog. Intrigued with the challenge of orchestrating a cohesive image together, we drew up a practical plan to attempt a series of truly collaborative paintings. We wanted to produce a body of work that neither of us would have created on our own. This is one of the reasons the *Pendulum/Pendula* paintings feel so pulled and pushed apart. They have exploded in the same way that in a heated discussion, people will be speaking out loud at the same time. As authors of our own predicament, we decided to include ourselves disguised and half hidden within the compositions, almost overcome by our accumulated subject matter, both psychologically and physically. Each of us had to struggle to accommodate what the other introduced. We agreed to a strategy of simple procedures. We took turns to gather objects and paraphernalia to photograph as chaotic grounds.

We each orchestrated photo sessions with the other as model: either partially disguising our faces with Mexican masks, or by wrapping our heads in transparent shopping bags, underlining the throwaway nature of some of our subject matter. We positioned ourselves autobiographically, but as outsiders in Mexico. Then, together, we took the photographic sources, and made collages from them, with which to create the imagery. Finally, we randomly chose sections of the compositions that each would paint, then passed the canvas to the other to finish. Getting the intensity balanced at each end required some final adjustments, because John built up his part of the imagery with a more solid, opaque approach, whereas I used my acrylic paint with a watercolour technique of transparent layers that had to be orchestrated to match, or at least arrive at a midpoint balanced between both treatments of the medium. An exhibition of the *Pendulum/Pendula* works was organized, opening in 1997 at the Instituto Nacional de Bellas Artes in San Miguel de Allende. There were several subsequent iterations of this show, both in Mexico and Canada, the most recent one occurring in 2015 in Nelson, BC.

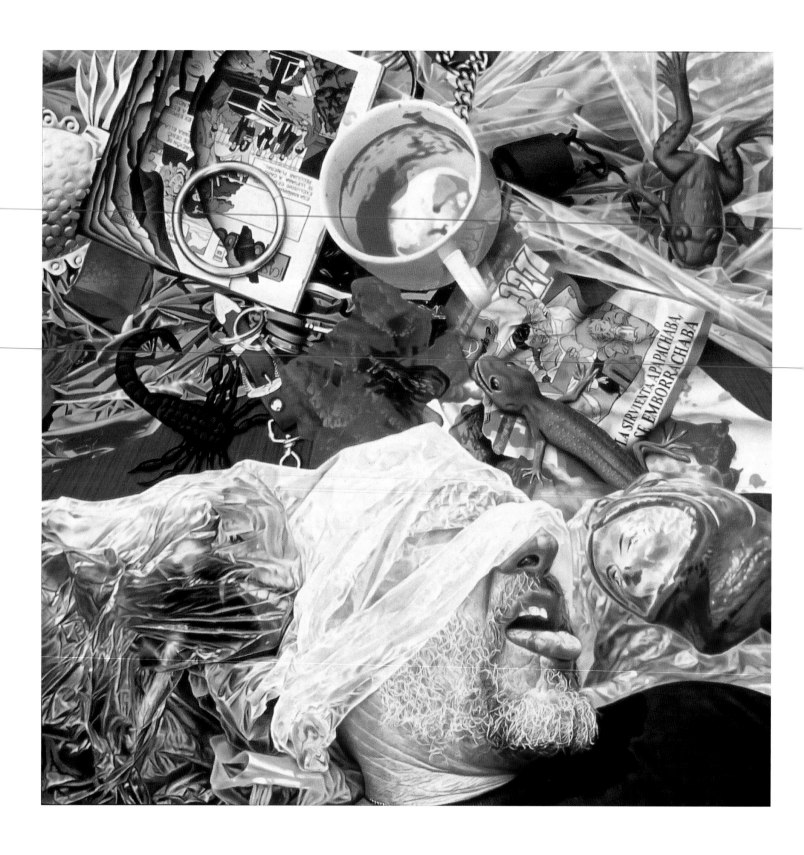

Table Manners /
Comportamiento de la Mesa, 1996,
acrylic on canvas,
152 x 152 cm.
Painted in collaboration with
Alexandra Haeseker.

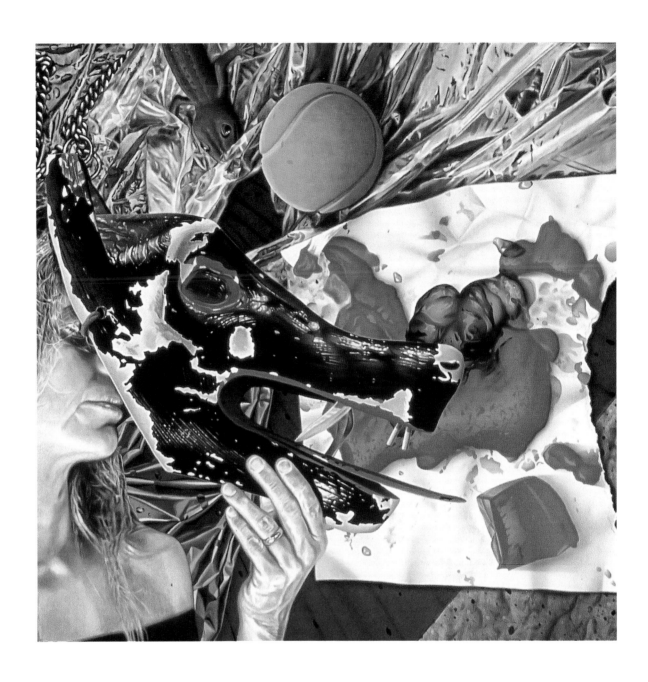

Pitch Black / Boca le Lobo, 1997,
acrylic on canvas,
91 x 91 cm.
Painted in collaboration with
Alexandra Haeseker.

Changing circumstances in both Canada and Mexico prompted John and Joice to make their decision to pull out of Mexico in 1999, after a decade of regular residency times, and to relocate in Kelowna, British Columbia, Canada. During their last sojourn in San Miguel, subject matter in John's continuing studio work became reflective of his putting things away: rolling up canvases, wrapping up stuff, knotting electrical cords, putting tools in their outlined shapes on pegboards. His compositions became less chaotic, and more ordered, simplified and organized. Previously acrid colour and wild disarray transmuted into muted earth tones and a greater simplicity. A shift had occurred. Whereas Mexico had once shattered John's control of order, now there was a calm of restoration apparent in his work. A final chapter might be found in his *Six Stones* series, begun after he arrived in Kelowna—simplified images of stones on mirrors, metaphoric for desire and loss of something intrinsically Mexican. In fact, in Mexico, maids, gardeners or trades people will often place small rocks or polished stones in houses—behind a vase, under a planter, beside a bed, or on a shelf—as talismans to ward off the evil eye or bad karma. It is a vernacular practice that in Mexico takes on a gravitas and functions as a secret but universal language. John Hall's paintings of simple stones void of context exist as memories of his leaving, where only these touchstones now inhabit his psyche about what was once exotic, erotic, surreal and everyday in Mexico—now far away and nowhere—3,000 miles from the Canadian border.

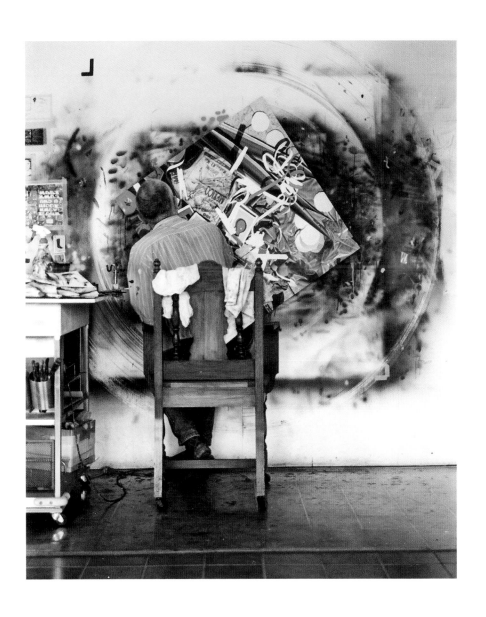

The artist at work in his San
Miguel studio on a painting
titled *Sirena*, from 1993.

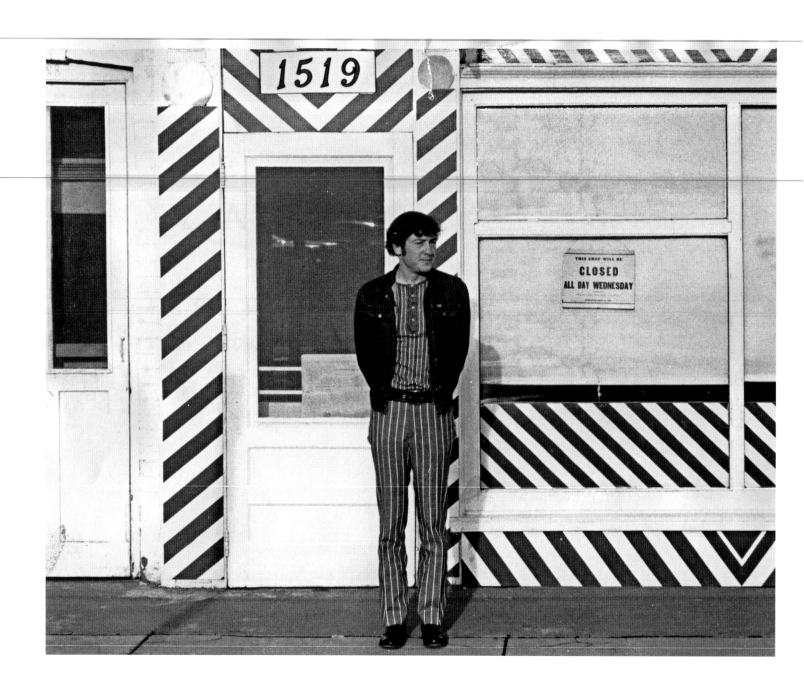

John Hall in 1970, published on the cover of Alberta College of Art catalogue for his 1970 solo show, It's the Real Thing. Hall was photographed in front of a beat-looking barber shop (to use the parlance of the time) that has been torn down since. Photo: Ron Moppett.

Born: Edmonton, Alberta, 1943

Education

1965	Four-year diploma in fine art, Alberta College of Art, Calgary, Alberta
1966	Study at Instituto Allende, San Miguel de Allende, Mexico

Teaching Experience

2009	Co-mentor with Harold Klunder, Toni Onley Artists' Project, Wells, British Columbia
2003–2004	Okanagan University College, Kelowna, British Columbia
2002	Okanagan University College, summer session, Kelowna, British Columbia
1998 to present	Professor Emeritus, University of Calgary, Calgary, Alberta
1971–1997	Professor of painting and drawing, University of Calgary, Calgary, Alberta
1970–1971	Studio instructor, Alberta College of Art, Calgary, Alberta
1969–1970	Visiting art instructor, Ohio Wesleyan University, Delaware, Ohio

Related Experience

2006	Curator of SEE: three decades of realist art, University of Calgary, Mezzanine Experience Gallery, University of Calgary, Calgary, Alberta
1989	Curator of New Alberta Art: Artist's Perspective, Glenbow Museum, Calgary, Alberta
1984	Curator of 6 Calgary Realists, Beaver House Gallery, Alberta Culture, Edmonton, Alberta, toured the province of Alberta
1979–1980	Invited to work at PS1, New York by the Institute for Art and Urban Resources, New York, and the Canada Council
1978–1980	Served on Canada Council Advisory Panel
1975	Elected to the Royal Canadian Academy of Arts (RCA)
1972 to present	Served on numerous Canada Council Juries (Art Bank, Short Term, Travel & Project Grants, Arts Grants)
1967–1969	Curator, Alberta College of Art Gallery, Calgary, Alberta

Selected Solo Exhibitions

2014	John Hall: paintings from the Flash and Candela series, Loch Gallery, Toronto
2011	The Still Life World of John Hall, Loch Gallery, Toronto
	The Still Life World of John Hall, Loch Gallery, Calgary, Alberta
2007	15: recent paintings from the Quodlibet Series, the Weiss Gallery, Calgary, Alberta
2007	Souvenir: John Hall, Two Rivers Gallery, Prince George, British Columbia
2006	ASCENDING PLEASURES II: John Hall's Still Life Paintings, Prairie Gallery, Grande Prairie, Alberta
2004	ASCENDING PLEASURES II: John Hall's Still Life Paintings, Vernon Public Art Gallery, Vernon, British Columbia
2003	John Hall: Quodlibet, Newzones Gallery of Contemporary Art, Calgary, Alberta
2000	John Hall: Three Decades, Newzones Gallery of Contemporary Art, Calgary, Alberta
1999	John Hall: New Paintings, Wynick/Tuck Gallery, Toronto
1997	John Hall: the New Paintings, Canadian Art Galleries, Calgary, Alberta
1996	John Hall: New Works, Canadian Art Galleries, Calgary, Alberta
	John Hall: la Disposición del Mercado, Art Gallery of the South Okanagan, Penticton, British Columbia

1995	John Hall: New Paintings, Wynick/Tuck Gallery, Toronto
1994	John Hall: Traza de Evidencia (Trail of Evidence), Glenbow Museum, Calgary, Alberta
	John Hall: Traza de Evidencia: New Paintings, Wynick/Tuck Gallery, Toronto
1993	John Hall: Traza de Evidencia, Museo de Arte Moderno, Mexico City, Mexico
	John Hall: Traza de Evidencia, Museo de Arte Contemporaneo, Aguascalientes, Mexico
1991	John Hall: New Paintings, Wynick/Tuck Gallery, Toronto
1989	Imitations of Life: John Hall's Still-Life Portraits, Agnes Etherington Art Centre, Queen's University, Kingston, Ontario, travelled to: Glenbow Museum, Calgary, Alberta; Kitchener/Waterloo Art Gallery, Kitchener, Ontario; Art Gallery of Nova Scotia, Halifax, Nova Scotia; Memorial University Art Gallery, St John's, Nfld.
1988	John Hall: New Paintings, Wynick/Tuck Gallery, Toronto
	John Hall: New Paintings, Susan Whitney Gallery, Regina, Saskatchewan
	John Hall: The Game's the Thing, Whyte Museum, Banff, Alberta (official Winter Olympics Arts Programme exhibition)
1987	John Hall: New Paintings Wynick/Tuck Gallery, Toronto
	John Hall: Recent Paintings, Canadian Art Galleries, Calgary, Alberta
1985	John Hall: New Paintings, Wynick/Tuck Gallery, Toronto
1982	John Hall: Paintings, Tourist Series/Toy Series, Southern Alberta Art Gallery, Lethbridge, Alberta, travelled to: Wynick/Tuck Gallery, Toronto; Edmonton Art Gallery, Edmonton, Alberta
1981	John Hall: New Paintings and Auxiliary Works, Aggregation Gallery, Toronto
	John Hall: Paintings and Auxiliary Works 1979–80, Mendel Art Gallery, Saskatoon, Saskatchewan, toured to Off Centre Centre, Calgary, Alberta
1980	John Hall: Paintings/Maquettes, Project Studio 1 (PS1), New York, NY
1979	John Hall: Paintings and Auxiliary Works 1969–1978, National Gallery of Canada, Ottawa, travelled to: Dunlop Art Gallery, Regina, Saskatchewan, The Gallery/Stratford, Stratford, Ontario, Memorial University Art Gallery, St John's, Newfoundland, Beaverbrook Art Gallery, Fredericton, New Brunswick
1978	John Hall: Paintings and Auxiliary Works 1969–1978, ACA Gallery, Alberta College of Art, Calgary, Alberta
1977	John Hall: Recent Paintings and Drawings, Latitude 53 Gallery, Edmonton, Alberta
	John Hall: New Work, Medicine Hat Jr College, Medicine Hat, Alberta
1972	John Hall: New Work, SUB Gallery, University of Alberta, Edmonton, Alberta
1970	It's the Real Thing: John Hall, ACA Gallery, Alberta College of Art, Calgary, Alberta

Selected Group Exhibitions

2015	Pendulum/Pendula (collaborative paintings with Alexandra Haeseker), Touchstones Nelson Museum of Art and History, Nelson, British Columbia
	OK BE ST, Headbones Gallery, Vernon, British Columbia
2014	90 X 90, Art Gallery of Alberta, Edmonton, Alberta
	Portraiture, Whyte Museum, Banff, Alberta
2013	OK Thaumaturgy aka Okanagan Wonders, Headbones Gallery, Vernon, British Columbia
	Made in Calgary: the eighties, Glenbow Museum, Calgary, Alberta
	Made in Calgary: the seventies Glenbow Museum, Calgary, Alberta
2012	Made in Calgary: The 1960s, Glenbow Museum, Calgary, Alberta
	Okanicon—Iconagan, Headbones Gallery, Vernon, British Columbia
	Au-Dela du Réel / Beyond Realism, Galerie de Bellefeuille, Montreal
2011	Okanagan Eyes, Okanagan Wise, Okanagan-ise, Headbones Gallery, Vernon, British Columbia
	Bring the Noise, Jarvis Hall Fine Art, Calgary, Alberta
	Traditions Illuminated: Celebrating the Halls, (four-person exhibition: Joice M Hall, Janine Hall, Jarvis Hall, John Hall), Art Gallery of Calgary, Calgary, Alberta

From our Collections: Portraits, Glenbow Museum, Calgary, Alberta

2009 Gallery without Walls: 50 years of the Calgary Allied Arts Foundation, Art Gallery of Calgary, Alberta

The Pendulum Collaborations: Haeseker and Hall, The Reach Museum and Gallery, Abbotsford, British Columbia

Chroma, Weiss Gallery, Calgary, Alberta

2008 Romantics, Weiss Gallery, Calgary, Alberta

2006 SEE: three decades of realist painting, Mezzanine Gallery, University of Calgary, Calgary, Alberta

MIMESIS (two-person exhibition with Joice M Hall), Penticton Art Gallery, Penticton British Columbia

Pendulum/Pendula (collaborative paintings with Alexandra Haeseker), Yukon Arts Centre, Whitehorse, Yukon

2005 The Feast: Food in Art, Art Gallery of Hamilton, Hamilton, Ontario

2004 Okanagan University College Faculty Exhibition, Okanagan University College, Kelowna, British Columbia

Okanagan University College Faculty Exhibition, Washington State University, Pullman, Washington

Pendulum/Pendula (collaborative paintings with Alexandra Haeseker), Rosemont Art Gallery, Regina, Saskatchewan

2003 Valley Lakescapes & Still Lifes (two-person exhibition with Joice M Hall), Art Ark Gallery, Kelowna, British Columbia

10th Annual Realism Invitational, Klaudia Marr Gallery, Santa Fe, New Mexico

Beyond the Beauty, Nickle Arts Museum, University of Calgary, Calgary Alberta

2002 Pendulum/Pendula (collaborative paintings with Alexandra Haeseker) Kelowna Art Gallery, Kelowna, British Columbia

Faculty Exchange Show, University of Calgary and Okanagan University College, Department of Art Gallery, University of Calgary, Calgary, Alberta

University of Calgary Faculty Exhibition, Nickle Arts Museum, University of Calgary, Calgary, Alberta

The Meanings of Death, MacKenzie Art Gallery, Regina, Saskatchewan

9th Annual Realism Invitational, Van de Griff/Marr Gallery, Santa Fe, New Mexico

Variety Pack: Pop Art's Legacy in Canada, Glenbow Museum, Calgary, Alberta

ALBUM: ACAD @ 75, Illingworth Kerr Gallery, Alberta College of Art and Design, Calgary, Alberta

University of Calgary Faculty Exhibition, Nickle Arts Museum, University of Calgary, Calgary, Alberta

2001 8th Annual Realism Invitational, Van de Griff/Marr Gallery, Santa Fe, New Mexico

University of Calgary Faculty Exhibition, Nickle Arts Museum, University of Calgary, Calgary, Alberta

2000 Introductions 2000, Glass Garage Gallery, West Hollywood, California

Silver, Illingworth H Kerr Gallery, Alberta College of Art and Design/the New Gallery, Calgary, Alberta

University of Calgary Faculty Exhibition, Nickle Arts Museum, University of Calgary, Calgary, Alberta

1999 High Realism: Paintings from the Collection of the Alberta Foundation for the Arts, The Prairie Gallery, Grande Prairie, Alberta

Pendulum/Pendula (collaborative paintings with Alexandra Haeseker), Museo de Arte de Queretaro, Queretaro, Mexico

University of Calgary Faculty Exhibition, Nickle Arts Museum, University of Calgary, Calgary, Alberta

1998 The Aitkens Collect, Nickle Arts Museum, University of Calgary, Calgary, Alberta

Foundation for the Arts: 25th Anniversary, Medicine Hat Museum, Medicine Hat, Alberta

Six Degrees of Separation (selections from the collection of the Alberta Foundation for the Arts), The Prairie Art Gallery, Grande Prairie, Alberta

LAYERS, Wynick/Tuck Gallery, Toronto

Pendulum/Pendula (collaborative paintings with Alexandra Haeseker), Museo de Arte Contemporaneo, Aguascalientes, Mexico

Pendulum/Pendula (collaborative paintings with Alexandra Haeseker), Pinacoteca de Nuevo Leon, Monterrey, Mexico

University of Calgary Faculty Exhibition, Nickle Arts Museum, University of Calgary, Calgary, Alberta

1997 Celebrating a Legacy: 25 Years of the Alberta Foundation for the Arts, Edmonton Art Gallery, Edmonton, Alberta

Pendulum/Pendula (collaborative paintings with Alexandra Haeseker), Centro Cultural el Nigromante, San Miguel de Allende, Guanajuato

group exhibition, Triangle Gallery, Calgary, Alberta

Informal Ideas 97.5—Colour and the Square, Wynick/Tuck Gallery, Toronto

University of Calgary Faculty Exhibition, Nickle Arts Museum, University of Calgary, Calgary, Alberta

1996 Just the Way It Is: Exploring Realism, Muttart Public Art Gallery, Calgary, Alberta

Artistas Canadienses en Mexico, Centro Cultural de ISSSTE, Celaya, Guanajuato Gto., Mexico

The Heritage Park Estates Collection, Gallery Lambton, Sarnia, Ontario

University of Calgary Faculty Exhibition, Nickle Arts Museum, University of Calgary, Calgary, Alberta

Informal Ideas: 96.3—The Middle Show, Wynick/Tuck Gallery, Toronto

Masquerade, Wynick/Tuck Gallery, Toronto

Still Life, Paul Kuhn Gallery, Calgary, Alberta

1995 50th ANNIVERSARY, Canadian Art Galleries, Calgary, Alberta

Mysteries of the Flesh, TD Square, Calgary, Alberta

Foo-Fat, Hall, Pico, Canadian Art Galleries, Calgary, Alberta

informal ideas: 95.5 (surround), Wynick/Tuck Gallery, Toronto

Cinco Dedos de Una Misma Mano, Canadian Embassy, Mexico City, Mexico

We Forgot the Horse, Canadian Art Galleries, Calgary, Alberta

Homey, Wynick/Tuck Gallery, Toronto

Gallery Artists, Oscar Roman Gallery, Mexico City, Mexico

Realism Revisited, Muttart Art Gallery, Calgary, Alberta

Faculty Exhibition, Alberta College of Art and Design, Calgary, Alberta

University of Calgary Faculty Exhibition, Nickle Arts Museum, University of Calgary, Calgary, Alberta

1994 Hidden Values: Ontario Corporations Collect, McMichael Canadian Art Collection, Kleinburg, Ontario, travelled to: Edmonton Art Gallery, Edmonton, Alberta

Opening Exhibition, Canadian Art Galleries, Calgary, Alberta

University of Calgary Faculty Exhibition, Nickle Arts Museum, University of Calgary, Calgary, Alberta

1993 University of Calgary Faculty Exhibition, Nickle Arts Museum, University of Calgary, Calgary, Alberta

1992 Works from the Canada Council Art Bank, exhibition in the Canadian Pavilion, Expo 1992, Seville, Spain

From Soup to Nuts: Pop Art, Its Legacy and the Culture of Consumption, Banker's Hall, Calgary, Alberta

Alberta College of Art Faculty Show, Illingworth Kerr Gallery, Alberta College of Art, Calgary, Alberta

University of Calgary Faculty Exhibition, Nickle Arts Museum, University of Calgary, Calgary, Alberta

1991 University of Calgary Faculty Exhibition, Nickle Arts Museum, University of Calgary, Calgary, Alberta

1990 Contemporary Realism, Art Gallery of Northumberland, Cobourg, Ontario

University of Calgary Faculty Exhibition, Nickle Arts Museum, University of Calgary, Calgary, Alberta

1989 University of Calgary Faculty Exhibition, Nickle Arts Museum, University of Calgary, Calgary, Alberta

Selections from the Permanent Collection, National Gallery of Canada, Ottawa

The Art Gallery of Hamilton: Seventy-Five Years, Art Gallery of Hamilton, Hamilton, Ontario

New Alberta Art: Artist's Perspective, Glenbow Museum, Calgary, Alberta

University of Calgary Faculty Exhibition, Nickle Arts Museum, University of Calgary, Calgary, Alberta

1988 Survey Alberta '88, Alberta College of Art Gallery, Alberta College of Art, Calgary, Alberta

University of Calgary Faculty Exhibition, Nickle Arts Museum, University of Calgary, Calgary, Alberta

1987 Cut, Wynick/Tuck Gallery, Toronto

Dreaming before Nature: Eight Calgary Artists, Edmonton Art Gallery, Edmonton, Alberta

inaugural exhibition in new location, Susan Whitney Gallery, Regina, Saskatchewan

Contemporary Painting in Alberta, Glenbow Museum, Calgary, Alberta

University of Calgary Faculty Exhibition, Nickle Arts Museum, University of Calgary, Calgary, Alberta

1986 Contemporary Realism from the Permanent Collection, Glenbow Museum, Calgary, Alberta

Looking at Myself, Off Centre Centre, Calgary, Alberta

The Arts in a Multi-Cultural Setting, Visva-Bharti University, Santiniketan, West Bengal, India

The Box in Art, Galerie L'Imagier, Hull, Quebec

University of Calgary Faculty Exhibition, Nickle Arts Museum, University of Calgary, Calgary, Alberta

1985 Pop Art—Selected Works from the Permanent Collection, National Gallery of Canada, Ottawa

A Measure of Success: The First Ten: 1975–1985, Illingworth Kerr Gallery, Alberta College of Art and Design, Calgary, Alberta

5+5, Off Centre Centre, Calgary, Alberta

New Works, (group exhibition featuring 25 Calgary artists), Wynick/Tuck Gallery, Toronto

University of Calgary Faculty Exhibition, Nickle Arts Museum, University of Calgary, Calgary, Alberta

1984 Recent Acquisitions, Art Gallery of Ontario, Toronto

Now Showing in Europe, Beaver House Gallery, Alberta Culture, Edmonton, Alberta

Recent Acquisition, Glenbow Museum, Calgary, Alberta

Seven Artists from Alberta: Art in This Region, Canada House Cultural Centre Gallery, London, England, organized by the Canadian House Cultural Centre Gallery and Alberta Culture, travelled to: Canadian Cultural Centre, Brussels, Belgium; Canadian Cultural Centre, Paris, France

University of Calgary Faculty Exhibition, Nickle Arts Museum, University of Calgary, Calgary, Alberta

1983 The Hand Holding the Brush, Self Portraits by Canadian Artists 1825–1983, London Regional Art Gallery, London, Ontario, travelled to Macdonald Stewart Art Centre, Guelph, Ontario; Art Gallery of Hamilton, Hamilton, Ontario; McCord Museum, Montreal, Quebec; Beaverbrook Art Gallery, Fredericton, New Brunswick, Mount Saint Vincent University Art Gallery, Halifax, Nova Scotia; Agnes Etherington Art Centre, Queen's University, Kingston, Ontario

University of Calgary Faculty Exhibition, Nickle Arts Museum, University of Calgary, Calgary, Alberta

Prepaid Miniature Art Sale, London Regional Art Gallery, London, Ontario

1982 The Winnipeg Perspective—Post Pop Realism, Winnipeg Art Gallery, Winnipeg, Manitoba

University of Calgary Faculty Exhibition, Nickle Arts Museum, University of Calgary, Calgary, Alberta

1981 Art Bank Exhibition, Art Gallery of the University of Lethbridge, Lethbridge, Alberta

Realism: Structure and Illusion, Macdonald Stewart Art Centre, Guelph, Ontario. Toured to Burlington Cultural Centre, Burlington, Ontario

Canada Council Art Bank Exhibition, Acadia University Art Gallery, Wolfville, Nova Scotia

University of Calgary Faculty Exhibition, the Nickle Arts Museum, University of Calgary,

1980 Mostly Smaller Works, Off Centre Centre, Calgary, Alberta

The Rose Museum Sells Out, Off Centre Centre, Calgary, Alberta

University of Calgary Faculty Exhibition, the Nickle Arts Museum, University of Calgary, Calgary, Alberta

RCA Alberta, the Nickle Arts Museum, Calgary, Alberta

Painting in Alberta: An Historical Survey, Edmonton Art Gallery, Edmonton, Alberta

Gallery Artists, Aggregation Gallery, Toronto

1979 Alberta Art, Alberta Art Foundation on Tour in Japan, travelled to: Sapporo, Obihiro, Tokyo, Kyoto, and Yokohama

Fifteen (Calgary artists), Walter Phillips Gallery, Banff, Alberta

1978 Realism in Canada, Norman MacKenzie Art Gallery, University of Regina, Regina, Saskatchewan

1977 Selections: Alberta Art Foundation, Glenbow Museum, Calgary, Alberta

Albertawork, juried show, ACA Gallery, Alberta College of Art, Calgary, Alberta

Alberta Paintings: The 50s & 60s, ACA Gallery, Alberta College of Art, Calgary, Alberta

1976 What's New, Edmonton Art Gallery, Edmonton, Alberta

17 Canadian Artists: A Protean View, Vancouver Art Gallery, Vancouver

John Hall: Paintings/Joice Hall: Celebrated Landscapes, Dalhousie University Art Gallery, Halifax, Nova Scotia

Spectrum, Montreal Museum of Fine Arts, Montreal

Eight Calgary Artists, Mendel Art Gallery, Saskatoon, Saskatchewan

John Hall/ Ron Moppett, University of Lethbridge, Lethbridge, Alberta

1975 Alberta Art Foundation travelling exhibition, Canada House, London, England, travelled to the Canadian Embassy, Brussels, Belgium, the Canadian Embassy, Paris, France; the Canadian Consulate, New York, NY; Place Bonaventure, Montreal, Quebec

University of Calgary Faculty Exhibition, University of Calgary Art Gallery, Calgary, Alberta

1974 Alberta Realists, Edmonton Art Gallery, Edmonton, Alberta

Nine out of Ten, Art Gallery of Hamilton, Hamilton, Ontario, travelled to: Kitchener/Waterloo Art Gallery, Kitchener, Ontario; The Gallery/Stratford, Stratford, Ontario

Faculty Exhibition (Universities of Alberta and Calgary), Glenbow Museum, Calgary, Alberta

1973 Alberta Art Foundation Inaugural Exhibitions, Edmonton and Calgary, Alberta

Manisphere (juried show, awarded honourable mention), Winnipeg, Manitoba

Alberta Art (organized by the Cultural Development Branch of the Government of Alberta), Banff Centre, Banff, Alberta

1972 Realism: Emulsion and Omission, Agnes Etherington Art Centre, Queen's University, Kingston, Ontario, University of Guelph Art Gallery, Guelph, Ontario

S.C.A.N. (Survey of Canadian Art Now), Vancouver Art Gallery, Vancouver

Art of the Provinces, Canadian National Exhibition, Toronto

National Juried Show, Agnes Etherington Art Centre, Queen's University, Kingston, Ontario

University of Calgary Faculty Exhibition, University of Calgary, Calgary, Alberta

four-artist show, Canadian Art Galleries, Calgary, Alberta

Art of the Twentieth Century, Montreal Museum of Fine Arts, Montreal

1971 Canada 4 & 3 (exhibition of contemporary Canadian art organized by the National Gallery of Canada), Canadian Cultural Centre, Paris, France

West '71, Edmonton Art Gallery, Edmonton, Alberta

43rd Annual, juried exhibition, Spokane Art Museum, Spokane, Washington

Environment '71, organized by the Cultural Development Branch of the Government of Alberta, Jubilee Auditorium, Calgary, Alberta

Alberta Society of Artists Juried Show, Edmonton Art Gallery, Edmonton, Alberta

91st Annual Exhibition of the Royal Canadian Academy, Montreal Museum of Fine Arts, Montreal, travelled to: Confederation Art Gallery, Charlottetown, Prince Edward Island

1970 Faculty Show, Ohio Wesleyan University, Delaware, Ohio

47th Annual (juried show), Akron Art Institute, Akron, Ohio

John and Joice Hall, University of British Columbia Fine Arts Gallery, Vancouver

1969 Environment '69, organized by the Cultural Development Branch of the Government of Alberta, Jubilee Auditorium, Calgary, Alberta

Cincinnati Biennial, Cincinnati Art Museum, Cincinnati, Ohio

All Alberta (juried show), Edmonton Art Gallery, Edmonton, Alberta

Manisphere (juried show, awarded first prize), Winnipeg, Manitoba

1968 Faculty Exhibition, ACA Gallery, Alberta College of Art, Calgary, Alberta

Manisphere (juried show, awarded first prize), Winnipeg, Manitoba

All Alberta (juried show), Edmonton Art Gallery, Edmonton, Alberta

Selected Corporate Collections

Cineplex-Odeon, Toronto and New York, New York
Lavalin Inc, Montreal, Quebec
NOVA Chemicals, Calgary, Alberta
Petro-Canada, Calgary, Alberta
Royal Bank of Canada, Montreal, Quebec, and Calgary, Alberta
Trimac Ltd, Calgary, Alberta
TransCanada, Calgary, Alberta

Selected Public Collections

Alberta Foundation for the Arts, Edmonton, Alberta
Art Gallery of Alberta, Edmonton, Alberta
Art Gallery of Hamilton, Hamilton, Ontario
Art Gallery of Nova Scotia, Halifax, Nova Scotia
Art Gallery of Ontario, Toronto
Canada Council Art Bank, Ottawa
Cape Breton University Art Gallery, Cape Breton, Nova Scotia
Carleton University Art Gallery, Ottawa
City of Calgary Civic Art Collection, Calgary, Alberta
Confederation Art Gallery, Charlottetown, Prince Edward Island
Department of Foreign Affairs, Government of Canada, Ottawa
Glenbow Museum, Calgary, Alberta
Government of Alberta, Edmonton, Alberta
Kitchener/Waterloo Art Gallery, Kitchener, Ontario
MacKenzie Art Gallery, Regina, Saskatchewan
Memorial University Art Gallery, St John's, Newfoundland
Mendel Art Gallery, Saskatoon, Saskatchewan
Montreal Museum of Fine Arts, Montreal, Quebec
National Gallery of Canada, Ottawa
University of Calgary, Calgary, Alberta
Winnipeg Art Gallery, Winnipeg, Manitoba

Awards

1974, 1984, 1990	University of Calgary Teaching Excellence Award
2002	Alumni Award of Excellence, Alberta College of Art and Design, Calgary, Alberta
1998	Appointed Professor Emeritus, University of Calgary, Calgary, Alberta
1996	One of fifteen Canadian artists to have streets named after them in the housing development Heritage Park Estates in Sarnia, Ontario
	Canada Council "A" Grant
1993	Calgary Regional Arts Foundation grant
	Alberta Foundation for the Arts grant
	PADAC Project Grant
1992	Canada Council "A" Grant
1984	Canada Council "A" Grant
1982	Canada Council Travel Grant
1979	Canada Council "A" Grant
1977	Canada Council Travel Grant
1975	Canada Council Travel Grant
	Elected to the Royal Canadian Academy of Arts (RCA)
1973	Canada Council Project Cost Grant

Commissions

1983	Foothills Hospital, Calgary, Alberta
1989	Royal Bank of Canada, Calgary, Alberta
1988	Cineplex-Odeon, Chelsea Theatre, New York, New York
1986	Expo '86 Poster, Vancouver
2013	TransCanada, Calgary

Selected Bibliography

Reviews and Articles

Ainslie, Patricia, "New Art Acquisitions", *Glenbow Magazine* (Calgary, Alberta), July/August, 1984, pp 4, 5.

_____, "New Alberta Art", *Glenbow Magazine* (Calgary, Alberta), fall, 1988, Vol 8, No 4, p 24.

Anonymous, "Imitations of Life: John Hall's still life portraits", *Art Gallery of Nova Scotia Journal*, 7/1, 1990, p 23.

Anonymous, "John Hall Interview", *Visual Arts Newsletter* (Edmonton: Alberta Culture), Vol 4, No 1, winter, 1982, pp 8, 9.

Balfour Bowen, Lisa, "Opting for Post-Pop", *Toronto Sunday Sun*, 30 April, 1989, p 56.

Barj, Santiago, "Boris Biskin visita a elliot y hall", *tiempo libre* (Mexico City), 30 April, 1993, p 62.

Barnard, Elissa, "Portraits of Still-Life: Hall's imagery questions perceptions of reality", *The Herald* (Halifax, Nova Scotia), 1 June, 1990.

Berman, Arthur, Untitled review, *News and Travel International* (London, England), 26 June, 1984.

Besant, Derek Michael, "John Hall—The Artist as Tourist", *artmagazine*, September/October, 1981, Vol 13, No 55, pp 46–47.

Bogardi, George, "Art that goes pop in the dark", *Chimo* (Montreal), December, 1981, pp 23–25.

Bowen, Lisa Balfour, "Canadian artists shine in Seville", *The Financial Post*, 11 April, 1992.

Burnett, David, "John Hall: Paintings and Auxiliary Works 1969–78", *artscanada*, Vol 37, no 234/235, April/May, 1980, p 40.

_____, "John Hall: New Paintings", *Canadian Art*, fall, 1985, Vol 2, No 3, pp 89–90.

Chandler, John Noel, "Review of 17 Canadian Artists: A Protean View", *artscanada*, Vol 33, October/November, 1976, p 56.

Dault, Gary Michael, "Ascending Pleasures", *Border Crossings*, Vol 13, No 3, August, 1994, pp 55, 56.

de Witt, Marijke, "PENDULUM/PENDULA: Two Artists Collaborate to Find the Balance between Beauty and Repulsion", *Atención San Miguel*, 26 April, 1999, pp 4–5.

Diaz, Benny, "Exposición Pictórica de Alexandra Haeseker y John Hall, en el Museo de Arte Contemporáneo", (Aguascalientes, Mexico) *PAGINA 24*, 7 February, 1998, p 27.

Dixon, Maria, "The Art of John Hall", *Artichoke*, spring, 1997, Vol 9, No 1, pp 36–38.

Garneau, David, "So you missed Artwalk but still want to see it", *FFWD Weekly* (Calgary), 26 September–2 October, 1996, p 13.

Dutt, Robin, Untitled review, *London Review of the Arts* (London, England), 15 June, 1984.

Dyens, Georges M, "Review of Prairies, Saidye Bronfman Centre", *vie des arts* (Montreal), Vol 19, issue 76, 1974, p 83.

Emerich, Luis Carlos, "Elliot y Hall, bien postmodern", *Novedades* (Mexico City), 9 April, 1993, pp C5–6.

Enright, Robert, "Odd Man Out: an interview with John Hall", *Border Crossings*, Vol 8, No 3, summer, 1989, pp 8–19.

Farrell, Jody, "Art of the Peace Symposium '06", *Art of the Peace*, journal of Art of the Peace

Visual Arts Association, *Grande Prairie*, Alberta, fall/winter, 2006, p 12.

Fry, Phillip, "John Hall at the National Gallery of Canada", *Parachute* (Montreal), spring, 1980, pp 9–11.

Gale, Ted, "John Hall: Beauty and Menace Held in a Box", *Ottawa Review*, October, 1979.

Garneau, David, "Imitations of Power: John Hall's Still-Life Portraits", *Artichoke* (Calgary), winter, 1990, pp 34–37.

Gustafson, Paula, "Glenbow offers colourful look at Alberta Realism", *Calgary Herald*, 12 April, 1989.

Hammond, Lois, "Extraordinary Images from an Ordinary Man", *Western Living magazine*, March, 1980.

Hernandez, Claudia, "Exponen Artistas canadienses en México", *Celaya AM* (various Mexican cities), section C, p 4.

Hookey, Darrell, "Sum Total of Two Mexican Experiences", *What's Up Yukon*, 15 September, 2006.

Joyner, Brooks, "A Protean Artist in Calgary", *Calgary Albertan*, 5 June, 1976, p 13.

_____, "His Works are now a Hallmark", *Sunday Tab* (Calgary), 19 November, 1978.

Laurence, Robin, "John Hall and Alexandra Haeseker: Pendulum/Pendula", *Preview magazine* (Vancouver), Vol 29, No 4, September/October, 2015, p 24.

Laviolette, Mary-Beth, "Cool & Precise Calgary Realist Painters", *City Scope* (Calgary, Alberta), September/October, 1985, pp 9, 12.

_____, "Hall's recent works force viewers to see mundane in new light", *Calgary Herald*, 29 April, 2000, p ES8.

Levine, Manny, "Museum of Modern Art Exhibits John Hall", *Atencion San Miguel* (San Miguel de Allende, Mexico), 26 March, 1993, p 3.

Longi, Ana Maria, "Caos, Inestabilidad e Incertidumbre de la Vida Contemporanea: John Hall", *Excelsior* (Mexico City), 2 March, 1993, p C2.

Lowndes, Joan, "Review of John Hall/Joice Hall Show", *Vancouver Sun*, 3 November, 1970.

McConnell, Clyde, "Two Albertans" (review of John Hall/Bob Carmichael show), *artscanada*, April, 1971, Vol 28, issue 154/155, p 75.

McGoogan, Ken, "Discover art on CD-ROM: Artist John Hall's work is now on disc", *Calgary Herald*, June 17, 1996, p B4.

McHugh, Marilyn, "John Hall Calls Himself a New Realist Painter", *Ottawa Sunday Post*, 7 October, 1979.

MacMasters, Merry, "John Hall, traza de evidencia y David Elliot, pintura", *la Jornada* (Mexico City), 10 March, 1993, p C11.

Mandel, Corrine, "John Hall at Aggregation Gallery", *artscanada*, Vol 28, July/August, 1981, pp 41–42.

Mays, John Bentley, "Calgary Artist finds inspiration in mass produced miscellany", *Globe and Mail*, 13 April, 1981.

_____, Untitled review, *Globe and Mail*, 6 October, 1982.

_____, "Hall's comfortable as the odd man out", *Globe and Mail*, 18 May, 1985, p E13.

Miyasaki, Holly, "Married to it: coupled artists show together", *Penticton Western News*, 12 July, 2006.

Nelson, James, "John Hall is hard at work in the Realm of New Realism", *Ottawa Citizen*, 23 November, 1979.

Moppett, Ron, "John Hall: Paintings and Auxiliary Works 1969–78", *Journal no 35*, National Gallery of Canada, 1979.

Ochoa, Guillermina, "Presencia del Arte Moderno Canadiense en Mexico. Inaugurada por David JS Winfield—John Hall y su Realismo ...", *El Sol de Mexico* (Mexico City), 15 March, 1993, p D4.

O'Meara, Dina, "John Hall: Ascending Pleasures II", *Galleries West*, Vol 5, No 3, fall/winter, 2006, p 41.

Pearson, Gary, "Kitsch par excellence", *Off-Centre magazine* (Kelowna, British Columbia), December, 2004.

Pellerine, Laura, "John Hall", *Side Street Review* (Toronto), Issue 6, winter, 2010, pp 75–83.

Priegert, Portia, "Tag Team Painting a Realistic Challenge: John Hall & Alexandra Haeseker clear the hurdles of creative collaboration," *Kelowna Daily Courier EVENT arts supplement*, 7–13 November, 2002, p 14.

_____, "A couple who paints together, exhibits together," *Kelowna Daily Courier EVENT arts supplement*, 17 June–1 July, 2003, p 14.

_____, "Interior Views: the Vivid Realism of Joice and John Hall," *Galleries West*, Vol 2, No 3, fall/winter, 2003, pp 12–13.

Ramirez, Rocio, "El arte canadiense presente en Mexico—Se inauguro la muestra Traza de Evidencia", *Diario de Mexico* (Mexico City), March, 1993, p C4.

Rapp, Otto, Untitled review, *Lethbridge Herald*, 6 December, 1982.

Rosenberg, Ann, "Review of 17 Canadian Artists: A Protean View", *artmagazine*, Vol 8, no 29, October/November, 1976, pp 18–21.

Schneider, Ed, "Startling realism at AGSO", *Penticton Herald*, 28 July, 2006.

Staples, David, "Strokes of Genius: Alberta's best painting and the next 10 works of artistic genius", *Edmonton Journal*, 23 May, 1999, section C, pp 6, 7.

Suche, Anne, "John Hall", *Western Living magazine*, February, 1988, p 118.

Tibol, Raquel, "El Canadiense John Hall en el mam", *Proceso* (Mexico City), #855, 22 March, 1993, pp 52–53.

Tousley, Nancy, "John Hall at ACA Gallery", *Calgary Herald*, 9 November, 1978.

_____, "John Hall at Off Centre Centre", *Calgary Herald*, 26 February, 1981.

_____, "Alberta Goes to Europe," *Visual Arts Newsletter* (Edmonton), Vol VI, No 3, June, 1984.

_____, "Centre Marks First Decade", *Calgary Herald*, 22 February, 1985.

_____, "Art works grace hospital", *Calgary Herald*, 23 June 23, 1985.

_____, "Calgary Artist's show well in Toronto", *Calgary Herald*, 5 October, 1985.

_____, "Roots, Rejections and Rewards in Calgary", *Canadian Art*, fall, 1986, Vol 3, No 3, pp 72–79.

_____, "Still-Lifes are signs of people, places, times", *Calgary Herald*, 22 November, 1987.

_____, "Souvenirs: John Hall's Symbols Reflect Games Culture", *Calgary Herald*, 19 February, 1988.

_____, "Portraits of Mexico striking", *Calgary Herald*, 17 February, 1994, p A23.

_____, "Artist Couples", *Calgary Herald*, 11 December, 1994, Section B.

_____, "Fast Forward", *Canadian Art*, spring, 1993, Vol 10, No 1, p 14.

_____, "People revealed by possessions", *Calgary Herald*, 12 January, 1990.

Turnbull, Glenna, "Two minds in one glance", *Capital News* (Kelowna, British Columbia), Showcase arts supplement, 5–11 December, 2002, p 3 and cover.

Turner, George, Untitled review, *London Review of the Arts* (London, England), June, 1984.

Urquiza, Sandra, "John Hall y David Elliot: Arte Pop y Folk Urbano en el Museo de Arte Moderno", *UNO guia semenal (suplemento de unomasuno)* (Mexico City), 21 March, 1993, p 6.

Varley, Christopher, "Tourist Series and Toy Series", *Update* (Edmonton: Edmonton Art Gallery), Vol 4, No 1, January/February, 1983, p 3.

Vázquez Lozano, Javier, "John Hall: Pintor de una Evolución que Agoniza", *ESPACIOS: Cultura y Sociedad* (Aguascalientes, Mexico), Año 3, no 12, November–December, 1993.

Velazquez Yerba, Patricia, "Desde Canada; Elliot y Hall, dos pintores entre lo mexicano y el arte pop", *El Universal* (Mexico City), March 1, 1993, section Cultural, pp 1 ,4.

Walker, Kathleen, "John Hall at National Gallery of Canada", *Ottawa Citizen*, 23 November, 1979.

Wylie, Liz, "Hall's art social commentary or glistening visual delights", *Capital News* (Kelowna, British Columbia), 24 November, 2010, p B12.

Books and Exhibition Catalogues

Ainslie, Patricia, and Mary-Beth Laviolette, *Alberta Art and Artists: an Overview*, Markham: Fitzhenry and Whiteside, 2007, pp xi, 85–87, 125, and 130.

Ares, Francois, *Au-Dela du Réel / Beyond Realism*, Montreal: Galerie de Bellefeuille, 2012, pp 41, 84.

Balkind, Alvin, *17 Canadian Artists: A Protean View*, Vancouver: Vancouver Art Gallery, 1976.

Besant, Derek, *John Hall: Traza de Evidencia*, Mexico City: Museo de Arte Moderno, 1992.

Burnett, David, *Masterpieces of Canadian Art from the National Gallery of Canada*, Edmonton: Hurtig Publishing, 1990, pp 22, 221.

Bringhurst, Robert, Geoffrey James, Russell Keziere, John Bentley Mays, and Doris Shadbolt, ed, *Visions: Contemporary Art in Canada*, Vancouver: Douglas & McIntyre Ltd, 1983, pp 181, 185.

Burnett, David and Marilyn Schiff, *Contemporary Canadian Art*, Edmonton: Hurtig Publishers Ltd, 1983, pp 171–172, 202.

Burnett, David, *Cineplex Odeon–The First Ten Years*, Toronto: Cineplex Odeon, 1989, pp 46, 47.

Devonshire Baker, Suzanne, *Artists of Alberta*, Edmonton: University of Alberta Press, 1980.

Donovan, Daniel, *Signs of the Spirit: The Donovan Collection at St Michael's College*, Toronto: University of St Michael's College, 2001, pp 7, 23.

Donavan, Daniel, *The Donovan Collection*, Toronto: University of St Michael's College, 2010.

Ewen, Anne, *Traditions Illuminated: Celebrating the Halls*, Calgary: Art Gallery of Calgary, 2011.

Fuller, Gregory, *Kitsch-Art: Wie Kitsch Zur Kunst Wird*, Cologne, Germany: DuMont Buchverlag, 1992, pp 23, 27, 80–83, 87, 92, 105, 115, and 187.

Joslin, Mark, *Dreaming Before Nature, Eight Calgary Artists*, Edmonton: Edmonton Art Gallery, 1987.

Kluyver-Cluysenaer, Margaret, *Realism: Emulsion and Omission*, Kingston: Agnes Etherington Art Centre, Queen's University, 1972.

Laviolette, Mary-Beth, *Contemporary '88 Calgary*, Calgary: Canadian Art Galleries, Virginia Christopher Galleries, and Paul Kuhn Fine Arts, 1988.

Laviolette, Mary-Beth, *An Alberta Art Chronicle: adventures in recent and contemporary art*, Canmore: Altitude Publishing, 2006, pp 39, 75, 134, 136, 213–214, 216, 240–242, 248, 251–252, 323–327, 337, 342, 386, 432–433, and 435.

Lipman, Marci and Louise Lipman, *Images: Contemporary Canadian Realism*, Toronto: Lester and Orpen Dennys, 1980, pp 20–21, 47.

MacKay, Allan, Diana Nemiroff, and Jeffery Spalding, *Survey Alberta '88*, Calgary: Alberta College of Art Gallery, 1988.

McConnell, Clyde, "John Hall", *John Hall: Paintings and Auxiliary Works 1969–1978*, Calgary: Alberta College of Art Gallery, 1978.

Madill, Shirley, *Post-Pop Realism: The Winnipeg Perspective 1982*, Winnipeg: Winnipeg Art Gallery, 1982.

Moppett, George, *8 Calgary Artists*, Saskatoon: Mendel Art Gallery, 1976.

_____, Untitled introduction to: *John Hall: Paintings and Auxiliary Works 1979–1980*, Saskatoon: Mendel Art Gallery, and Off Centre Centre, Calgary, 1981. Catalogue also contains a published interview between the artist and Carroll Moppett.

Moppett, Ron, "Introduction", in *John Hall: Paintings and Auxiliary Works 1969–1978*, Calgary: Alberta College of Art Gallery, 1978.

_____, *John Hall: Paintings*, Halifax: Dalhousie University Art Gallery, 1976.

Murray, Joan, *The Best Contemporary Canadian Art*, Edmonton: Hurtig Publishers, 1987, p 76.

_____, *Canadian Art in the Twentieth Century*, Toronto: Dundurn Press, 2000, pp 185, 188–189.

Oakes, Julie, *Okanagan Eyes Okanagan Wise Okanagan-ize*, Vernon, British Columbia: Headbones Gallery, 2011, pp 26–27.

_____, *Okanicon—Iconagan*, Vernon, British Columbia: Headbones Gallery, 2012.

_____, *OK.BE.ST.* Vernon, British Columbia: Headbones Gallery, 2015.

Reid, Dennis, *A Concise History of Canadian Painting*, Toronto: Oxford University Press, 1988, pp 354–356.

_____, *A Concise History of Canadian Painting*, Toronto: Oxford University Press, 2012 (third edition), pp 350–352, 461.

Rochfort, Desmond, "Pendulum Pendula: Collaborative Synthesis", in *Pendulum/Pendula*, Kelowna: Kelowna Art Gallery, 2002, pp 7–23.

Stacey, Robert, *The Hand Holding the Brush: Self Portraits by Canadian Artists*, London: London Regional Art Gallery, 1983.

Swain, Robert and Robert Fulford, *Hidden Values: Contemporary Canadian Art in Corporate Collections*, Vancouver: Douglas & McIntyre, 1994, pp 32, 62, 81.

Theberge, Pierre, *Canada 4 & 3*, Paris: Centre Culturel Canadien, 1971.

_____, Untitled statement, *John Hall: Paintings and Auxiliary Works 1969–1978*, Calgary: Alberta College of Art Gallery, 1978.

Tousley, Nancy, "John Hall. Paintings.Tourist Series/Toys Series", *John Hall. Paintings. Tourist Series/Toys Series*, Lethbridge: Southern Alberta Art Gallery, and Wynick/Tuck Gallery, Toronto, 1982.

_____, *Seven Artists from Alberta: Art in this Region*, London, England: Canada House Cultural Centre Gallery and Alberta Culture, Government of Alberta, 1984.

_____, "John Hall's Still-Life Portraits", *Imitations of Life: John Hall's Still-Life Portraits*, Kingston, Ontario: Agnes Etherington Art Centre, Queen's University, 1989.

Varga, Vincent, *Aspects of Contemporary Painting in Alberta*, Calgary: Glenbow Museum, 1987.

Wood, George, Untitled text, *It's the Real Thing: John Hall*, Calgary: Alberta College of Art Gallery, 1970.

Zimon, Kathy E, *Alberta Society of Artists: The First Seventy Years*, Calgary: University of Calgary Press, 2000, pp 3, 54, 115, plate 71.

Online publications

Boulet, Roger, *La Disposición del Mercado*, online catalogue accompanying the 1996 Art Gallery of the South Okanagan exhibition La Disposición del Mercado: Paintings by John Hall, http://www.pentictonartgallery.com/scms.asp?node=La%20Disposici%F3n%20del%20 Mercado:%20Paintings%20by%20John%20Hall

A Family of Painters (video made in 2011 for Alberta Primetime in conjunction with the Art Gallery of Calgary's exhibition Traditions Illuminated: Celebrating the Halls), http://www. albertaprimetime.com/Stories.aspx?pd=2363

Video/CD-ROM Productions

Ascending Pleasures II—John Hall's Still Life Paintings, CD ROM catalogue to exhibition, introduction by Ken McGoogan, Vernon, British Columbia: Vernon Public Art Gallery, 2004.

The Canadian Collection of the National Gallery of Canada on CD-ROM), Ottawa: National Gallery of Canada, 1997.

Dault, Gary Michael, *Ascending Pleasures: the Art of John Hall*, CD-ROM published by Carbon Media, 1995.

From Idea to Image, video, Calgary: Glenbow Museum, 1989.

Ideas and Inspiration: Contemporary Canadian Art, Heartland Motion Pictures Inc CD ROM produced for Saskatchewan Education, 1995.

Investing in Art, episode 4, half-hour video profiles of three Alberta-based artists. Edmonton: Alberta Foundation for the Arts, 1992.

John Hall, short film produced by Big Money Pictures for the Bravo Channel, 2002.

NUTV, untitled ten-minute video profile, Calgary: University of Calgary, 1992.

John Hall is represented by the Loch Gallery, Toronto, Winnipeg, Manitoba and Calgary, Alberta, Canada.

AUTHORS' BIOGRAPHIES

Alexandra Haeseker (BFA, ACAD, MFA, RCA) was born in The Netherlands in 1945. She immigrated to Canada in 1955 and currently lives outside Calgary, Alberta. She is a Lecturer Emeritus at the Alberta College of Art and Design, having taught there from 1973 to 2003. Haeseker was awarded the Canadian Immigrant of Distinction Award for 2006. Her recent solo exhibitions have been at the Centro de Arte Moderno, Madrid in 2014, The Lamego Art Museum in Portugal in 2014 and most recently a large-scale installation for the Musée des Beaux-Arts in Liège, Belgium, in 2015.

Liz Wylie has been the Curator of the Kelowna Art Gallery in Canada since 2007, and is the organizer and curator for this book and exhibition, John Hall: Travelling Light: a 45-year Survey of Paintings. Previously she has lived in Saskatoon and Edmonton, before living and working in Toronto for twenty years. She held the position of University of Toronto Art Curator for eleven years. In addition to her work as a curator, Wylie has been writing reviews and articles on contemporary and historical Canadian art since 1977. In 2009 she launched the programming of a new satellite gallery space at the Kelowna International Airport featuring commissions of new works by artists of British Columbia's Okanagan Valley. Her recent publications include monographs on Canadian artists Keith Langergraber, John Hartman, Bill Rodgers, and Landon Mackenzie. Wylie holds an MFA in art history from Concordia University in Montreal. She is a past president of the Ontario Association of Art Galleries.

LIST OF WORKS
IN THE EXHIBITION

1 *Garbage Triptych*, 1969, acrylic on canvas, 122 x 305 cm. Collection of the Alberta Foundation for the Arts.

2 *Charlie's*, c 1968, ink on paper, 13 x 20 cm. Collection of the artist.

3 *Muro*, 1966, ink on paper, 15 x 20 cm. Collection of the artist.

4 *Taxi*, c 1968, ink on paper, 13 x 20 cm. Collection of the artist.

5 *Untitled Diptych*, 1969, acrylic on canvas, 183 x 137 cm. Collection of the artist.

6 *Pepsi*, 1970, acrylic on canvas, 244 x 183 cm. Collection of the Canada Council Art Bank / Collection de la Banque d'oeuvres d'art du Conseil des arts du Canada.

7 *Doll*, 1971, acrylic on canvas, 162 x 411 cm. National Gallery of Canada, Ottawa. Purchased 1972.

8 *Drum*, 1972, acrylic on canvas, 218 x 406 cm. Collection of the Alberta Foundation for the Arts.

9 *Pilot*, 1976, acrylic on canvas, 223 x 155 cm. Collection of the Canada Council Art Bank / Collection de la Banque d'oeuvres d'art du Conseil des arts du Canada.

10 *Bondage Egg*, 1976, acrylic on panel, 18 x 18 cm. Collection of Carroll Taylor-Lindoe.

11 *Art Deco Buckle*, 1976, acrylic on panel, 18 x 18 cm. Collection of the artist.

12 *White Shoe*, 1976, acrylic on panel, 18 x 18 cm. Collection of the Canada Council Art Bank / Collection de la Banque d'oeuvres d'art du Conseil des arts du Canada.

13 *Christmas Light*, 1976, acrylic on panel, 18 x 18 cm. Collection of the Canada Council Art Bank / Collection de la Banque d'oeuvres d'art du Conseil des arts du Canada.

14 *Tango*, 1977, acrylic on canvas, 157 x 157 cm. Collection of the artist.

15 *Grace*, 1976, acrylic on canvas, 157 x 157 cm. City of Calgary, Civic Art Collection. Gift of the Calgary Allied Arts Foundation, 1976.

16 *California Summer*, 1979, acrylic on canvas, 152 x 152 cm. Collection of the Winnipeg Art Gallery. Gift of the Volunteer Committee to the Winnipeg Art Gallery, G-81-104 a.

17 *Cover*, 1980, acrylic on canvas, 112 x 112 cm. Collection of the Art Gallery of Hamilton. Gift of the Lillian and Leroy Page Charitable Foundation, Estate of E L Steiner, Mabel Waldon Thompson Estate, and The Canada Council Art Bank, 1981.

18 *Tourist IV*, 1980, acrylic on canvas, 61 x 61 cm. Private collection.

19 *Handcuffs*, 1982, acrylic on canvas, 61 x 61 cm. Collection of the artist.

20 *Rubber Fly*, 1982, acrylic on canvas, 61 x 61 cm. Collection of the artist.

21 *Mosaic Fragment*, 1984, acrylic on panel, 24 x 24 cm. Collection of the artist.

22 *Indigo*, 1986, acrylic on canvas, 152 x 152 cm. Collection of Glenbow Museum, Calgary, Alberta.

23 *Flame*, 1988, acrylic on canvas, 152 x 152 cm. Collection of the artist.

24 *Zacatecas*, 1988, acrylic on canvas, 61 x 61 cm. Collection of Wendy Toogood/Don Mabie.

25 *Sinaloa*, 1988, acrylic on canvas, 61 x 61 cm. Collection of the artist.

26 *Campeche*, 1988, reworked in 2002, acrylic on canvas, 61 x 61 cm. Private collection.

27 *Angel*, 1989, acrylic on canvas, 152 x 152 cm. Private collection.

28 *Icon*, 1990, acrylic on canvas, 91 x 91 cm. Private collection.

29 *Gerda & Marijke*, 1991, acrylic on canvas, 152 x 152 cm. Collection of the Alberta Foundation for the Arts.

30 *Tattoo*, 1991, acrylic on canvas, 61 x 61 cm. Collection of the artist.

31 *Muñeca*, 1992, acrylic on canvas, 152 x 229 cm. Collection of the artist.

32 *Rain*, 1994–2004, acrylic on canvas, 63 x 94 cm. Collection of the artist.

33 *Calypso Warrior*, 1994, acrylic on canvas, 91 x 91 cm. Collection of Graham & Valerie Bailey.

34 *Nuclear Fever*, 1994, acrylic on canvas, 213 x 168 cm. Collection of Loch Gallery, Winnipeg.

35 *Rhapsody* formerly S6, 1995, acrylic on panel, 15 x 23 cm. Collection of the artist.

36 *S1*, 1995, acrylic on panel, 23 x 15 cm. Collection of Shanna Fromson.

37 *S4*, version 2, 1995, acrylic on panel, 15 x 23 cm. Private collection.

38 *S5*, 1995, acrylic on panel, 15 x 23 cm. Collection of the artist.

39 *K5*, 1995, acrylic on panel, 15 x 23 cm. Collection of the artist.

40 *K6*, 1995, acrylic on panel, 23 x 15 cm. Collection of the artist.

41 *K7*, 1995, acrylic on panel, 23 x 15 cm. Collection of the artist.

42 *Mask 1*, 1995, acrylic on panel, 15 x 23 cm. Collection of the artist.

43 *Mask 7*, 1995, acrylic on panel, 15 x 23 cm. Private collection.

44 *Mask 8*, 1995, acrylic on panel, 23 x 15 cm. Collection of the artist.

45 *Mask 9*, 1995, acrylic on panel, 23 x 15 cm. Private collection.

46 *Scar*, 1995, acrylic on canvas, 152 x 185 cm. Collection of the artist.

47 *Dishes*, 1998, acrylic on canvas, 45 x 68 cm. Collection of the Alberta Foundation for the Arts.

48 *Tar*, 1998, acrylic on canvas, 45 x 68 cm. Collection of the Alberta Foundation for the Arts.

49 *3.02.99*, 1999, acrylic on canvas, 61 x 91 cm. Collection of the artist.

50 *Arrow*, 2000, acrylic on canvas, 61 x 91 cm. Collection of the artist.

51 *Tape Elena*, 2000, acrylic on canvas, 30 x 45 cm. Collection of Elena Evanoff.

52 *Not Yet*, 2001, acrylic on canvas, 61 x 91 cm. Collection of the artist.

53 *Echo (Six Stones)*, 2001, acrylic on canvas, 61 x 91 cm. Collection of the artist.

54 *Pause (Six Stones)*, 2001, acrylic on canvas, 61 x 91 cm. Collection of the artist.

55 *Miracles and Monsters*, 2005, acrylic on canvas, 152 x 229 cm. Collection of Dean Turner.

56 *Burst (Six Stones)*, 2006, acrylic on canvas, 61 x 91 cm. Collection of the artist.

57 *Quodlibet XLVII*, 2008, acrylic on canvas, 30 x 30 cm. Collection of the artist.

58 *Passage*, 2008, acrylic on canvas, 61 x 91 cm. Private collection.

59 *Quodlibet L*, 2008, acrylic on canvas, 30 x 30 cm. Collection of the artist.

60 *Jump*, 2009, acrylic on canvas, 76 x 76 cm. Collection of the Alberta Foundation for the Arts.

61 *Avalanche 1*, 2009, acrylic on canvas, 20 x 25 cm. Private collection.

62 *Avalanche 2*, 2009, acrylic on canvas, 20 x 25 cm. Private collection.

63 *Orbit*, 2009, acrylic on canvas, 30 x 30 cm. Collection of the artist.

64 *Krunch*, 2010, acrylic on canvas, 61 x 61 cm. Collection of the artist.

65 *Ka-Pow*, 2010, acrylic on canvas, 152 x 229 cm. Collection of the artist.

66 *Rattle*, 2011, acrylic on canvas, 152 x 203 cm. Collection of the artist.

67 *Candela: Turquoise/Magenta*, 2012, acrylic on canvas, 20 x 25 cm. Collection of the artist.

68 *Candela: Bolero Red/Calypso Teal*, 2012, acrylic on canvas, 40 x 51 cm. Collection of the artist.

69 *Candela: Cape Verde/Adobe Dust*, 2012, acrylic on canvas, 46 x 61 cm. Collection of the artist.

70 *Candela: Redstone/Wizard*, 2012, acrylic on canvas, 36 x 46 cm. Collection of the artist.

71 *22 Hayley Wickenheiser*, 2013, acrylic on canvas, 91 x 91 cm. Private collection.

72 *Flash: Juke*, 2015, acrylic on canvas, 91 x 91 cm. Collection of the artist.

© 2016 Black Dog Publishing Limited, the author
and the artist. All rights reserved.

Black Dog Publishing Limited
10A Acton Street, London WC1X 9NG
United Kingdom

t. +44 (0)207 713 5097
f. +44 (0)207 713 8682
info@blackdogonline.com
www.blackdogonline.com

All opinions expressed within this publication are those
of the authors and not necessarily of the publisher.

Designed by Ana Teodoro at Black Dog Publishing.

Cover: *Jump*, 2009, acrylic on canvas, 76 x 76 cm.
Collection of the Alberta Foundation for the Arts.
Back cover: *Krunch*, 2010, acrylic on canvas, 61 x 61 cm.
Collection of the artist.

British Library Cataloguing-in-Publication Data.
A CIP record for this book is available from the British Library.

ISBN 978 1 910433 86 7

Black Dog Publishing is an environmentally responsible
company. *John Hall: Travelling Light: A 45-Year Survey of
Paintings* is printed on sustainably sourced paper.

art design fashion
history photography
theory and things

www.blackdogonline.com